D0099765

About the Author

Diana Martin is the principal in a Cincinnati-based firm that provides editorial and marketing communication services to clients whose publication needs include books, magazines, newsletters and brochures.

In addition to *Graphic Design: Inspirations and Innovations*, Diana has coauthored three other books on design and illustration: *Fresh Ideas in Letterhead and Business Card Design*, *Getting Started in Airbrush*, and *How to Airbrush T-shirts and Other Clothing*. She is currently interviewing designers for her fifth book, *Street Smart Design*, which will be published in 1996.

Graphic Design: Inspirations & Innovations. Copyright ©1995 by Diana Martin. Printed and bound in China. All rights reserved. No part of this book may be reproduced in any form or by any electronic or mechanical means including information storage and retrieval systems without permission in writing from the publisher, except by a reviewer, who may quote brief passages in a review. Published by North Light Books, an imprint of F&W Publications, Inc., 1507 Dana Avenue, Cincinnati, Ohio 45207. 1-800-289-0963. First edition.

99 98 97 96 95 5 4 3 2 1

Library of Congress Cataloging-in-Publication Data
Martin, Diana.
 Graphic design : inspirations and innovations / by Diana Martin.
 p. cm.
 Includes index.
 ISBN 0-89134-640-6
 1. Graphic arts—United States—Design. I. Title.
NC998.5.A1M27 1995
741.6'0973—dc20

 94-43748
 CIP

Edited by Mary Cropper
Cover design by Lori Siebert and Ben Meyers, Siebert Design Associates
Interior design by Clare Finney

The permissions on pages 125-131 constitute an extension of this copyright page.

This book is dedicated to creativity

We would like to thank all of the stunningly talented designers who agreed to be in this book, and who were so generous with their time and their thoughts.

Contents

Working Out Your Ideas

All the designers in this section talk about how they brought to life these ideas in particular and about the process of traveling from concept to comp in general. Some of the solutions will seem natural and inevitable; other solutions will perhaps surprise and startle you. But all were the right approach to turning the spark of an idea into the glowing fire of the final piece.

Presenting Ideas to the Client

Once you've got a great idea, how do you convince the client to go along with you, especially when the idea is unorthodox or innovative? You don't need a great reputation or expensive elaborate presentations. What you do need is a client relationship based on trust and mutual respect, which provides a place for creative freedom to blossom and grow.

This book is a tribute to the power of the idea. An idea can transform the simple into the sublime, the ordinary into the outrageous, or the barely good into the great. A good idea that has been well executed can knock the socks off both the client and the intended audience. But a good idea that's poorly executed or awkwardly presented may never get off the drawing board, much less past the client and out to the audience. Granted that it does take more than an idea to shape good communication design, it still starts with that tiny germ, or seed if you prefer, that is sparked by creativity and eventually blossoms into a great message and terrific design.

The idea—where it comes from, how it's translated into tangible form, and how the client is persuaded to accept it—is a

Knowing that there are as many approaches to creativity as there are designers, we chose to break the process into three stages: (1) where ideas come from; (2) how an idea is worked into tangible form; and (3) how it is then presented to the client. Then we asked two or three questions related to each stage. We began with "How do you get ideas? What techniques do you use?" and whether they did research on a client or a project. We also asked, "What or who has been an inspiration for you?" and what reference materials, such as books or an idea clip file, they kept on hand. We then asked the designers how they turn an idea into a concept and then into a printed piece. Finally we asked how they get clients to accept their ideas—and if they ever get good ideas

Introduction

perennial topic of conversation at design conferences and seminars. In order to learn more about this elusive creature, we asked a group of outstanding designers to each answer ten questions about the creative process and loan us a sample of their work that illustrated the outcome of that process. The responses and representative work of seventy-five of those designers fill the remainder of this book. Unfortunately, we couldn't include every word of every answer, or no one would be able to lift this book, much less read it. We've tried to select responses that illustrate the differences between designers' creative processes or otherwise shed an interesting light on the whole notion of the idea. (Some additional comments have been quoted within this introduction, too.)

from clients. We also asked how they create good, long-term working relationships with clients.

So, let's start this tribute to the creative process with a look at the place—actually places, since there are far more than one—that ideas come from. Ask seventy-five designers that question, and you'll get seventy-five different answers. Some discover ideas through free association, other designers brainstorm, still others seek ideas on the sketch pad, and other designers escape from the studio entirely in order to find ideas on the jogging trail or in the shower.

Still others discover the solution in the creative problem itself. Rick Tharp, THARP DID IT, notes, "I do believe that ideas already exist within the problems

themselves. It's just a matter of pulling them out and presenting them as solutions. This is probably why I don't have a recognizable style to my work. I try not to let my artistic preferences or stylistic tendencies dictate the direction of a design solution. If the answer is inherently part of the question, then I let the problem dictate the solution."

On the other hand, this diverse group of designers did have a few approaches in common. Almost all stressed the importance of researching a project. As Forrest Richardson, Richardson or Richardson, noted, "Information is invaluable, always." That view was strongly seconded by Michael Jager, Jager DiPaola Kemp: "Every design project must have a foundation of research to exist." Some designers research a project by meeting with the client and then proceeding to learn about the client and the business from top to bottom and inside to out. Others research the competition and thoroughly examine all the communication materials in the same environment where this client's message must compete for attention. Other designers study art history, period materials, or the creative output of other fields to find elements of an appropriate idea.

When asked what they turn to for inspiration, all the designers cited some type of visual influence. Designers collect every size, shape and type of visual reference imaginable. Most have libraries of books and magazines—design, photography, architecture, fine art, fashion, interior decorating and even children's books. Old books on typography and examples of it, such as posters and advertisements, were also frequently mentioned. Many keep clip files of unused and rejected ideas for future projects. A number of designers collect images—photographs, sketches, illustrations and other visuals—and even

objects they find inspiring.

We heard about collections of Art Deco objects, cigar boxes, toys, matchbook covers, ties, ephemera and album covers, or cover art. Travel, literature, nature, music and museums were also mentioned as sources of inspiration. A few designers mentioned the design annuals as a means of keeping up with trends and the competition, but none indicated the annuals were a major source of ideas. Some designers did mention being inspired by others in the field, however, with Saul Bass, Paul Rand, Milton Glaser, Lou Dorfsman and Woody Pirtle being most frequently mentioned. Perhaps Robert Louey, Louey/Rubino Design Group, summed it up best with this statement: "The world is full of inspiration. To notice it is the technique."

Once an idea has appeared, it has to be given shape and form in order to be appreciated by others. Earl Gee, Earl Gee Design, observed that "The key is to have the printed piece match the energy and vitality of the original sketch. When the printed piece retains that energy, the idea will connect with its audience." Most of the designers whose work is shown here start by sketching out ideas—often dozens of sketches—and then moving into other mediums, including the computer. Although the process is much the same, the actual techniques and materials used depend on the type of project and the client's needs. Each piece has its own strategy and objectives so it is unlike any project that came before or that will come after it. Experimentation, such as exploring different concepts, approaches and materials, plays a key role in finding the right way to clothe the idea in paper, computer image, ink and visuals.

Often a designer will start the development stage with several ideas with strong potential that must then be elimi-

nated until only the best survive. Many designers involve the client in the development process from an early stage in order to avoid spending a lot of time refining an approach that is wrong for that client. Although a particular client may need to see five or more ideas, this situation is not typical. Most of these designers present roughly three ideas at most; they often show only one idea when it's one they feel very strongly about.

An in-house critiquing process is, however, fairly common. Even in small studios, the opinions of others are sought. In medium-sized to large studios, several designers may work up ideas into rough comps from which one or two ideas are selected for final, detailed comps. The amount of detail and work that goes into comps is largely driven by the visual sophistication of the client. Some can, and do, approve ideas on the basis of rough sketches and scribbled thumbnails. Other clients (some designers said "most" clients) need to see a comp that provides a close approximation of the finished piece.

Although several innovative designers whose work appears in this book find inspiration at and work out ideas on the computer, the majority find the computer most helpful as a comping and presentation tool. (One designer observed that the computer may be only a tool to some, but it does allow other designers to come up with ideas that wouldn't have been possible or perhaps even imagined before its introduction into the studio.) As a design and presentation tool, the computer comes in for its share of praise and blame for the current state of design.

And finally, there's the presentation to the client, the gatekeeper to the world where an idea can be seen and judged on its merits—and appearance—by its intended audience. Michael Jager suggests

that "If you listen well, build your base of knowledge, determine a distinctive path or solution, and then deliver your finding passionately, your work will be accepted. You must be knowledgeable to be believed, and you must understand the problem before you can hope to find a solution." This view is seconded by John Norman, NIKE, Inc.: "If you've done the proper research and you have a good understanding about the business of the client, then there is no conflict involved in promoting your ideas. It's the holes that are the problem, not the cheese."

When asked how they persuade a client to see the merits of their ideas, especially those ideas that are innovative, unorthodox or controversial, many of these designers mentioned the importance of having a good relationship with every client. John Norman points out that the client-designer relationship is a two-way street: "Each side has the responsibility to trust the other. A designer has to be willing to take the time to understand the history, goals and products of the client. The designer must be a good listener and be concerned about the client's needs. The client must respect the design process and be willing to be educated about the design process. This will enable the client to grasp the essence of a design concept, to understand where a designer is going with an idea. If you can get this kind of relationship going with a client, great work *will* result."

Most designers mentioned the importance of listening to the client as a key to developing a good client relationship. These designers also reported getting good ideas from their clients, whether indirectly or directly. Michael Jager points out that "You must never forget that no one can know more about your client's situation than your client. The moment you neglect

to recognize the client's perspective and the client as a source of ideas, you will quickly be talking to yourself."

Another key to a good, long-term client relationship is understanding the client's business, needs and goals for the project. Consistently delivering on-target communications designs not only earns repeat business but builds the kind of trust that lets designers be more innovative in their solutions. Robert Louey observed, "A good client will express their vision. A good designer becomes a caretaker to that vision and transforms it into a great design, whatever the final form will be." The ability to provide logical support for a design solution, especially support that shows the benefits for the client, also plays a role in this area.

Of course, what happens to an idea after it's launched into the world is another story altogether and, therefore, left for another book. We hope that you'll find this book exciting and inspiring as well as enjoyable. Although we cannot claim to have established the true and absolute identity of either the idea or the creative process—like the chameleon, they change to suit their surroundings—we hope the designers whose insights appear between these covers have shed some illumination on the subject.

Where Do Ideas

We asked, "Where do your ideas come from?" and "What inspires you?" The answers we got were as varied as the work and personalities of the designers who share here their thoughts on that topic. Most of the designers gave more than one answer to those questions: The inspiration for each project may be different from the one that preceded or followed it. For some of the projects shown here, the inspiration came from the client or the product or the communications problem to be solved. Not surprisingly most of the sources were, in one way or another, predominantly visual, including photographs, sketches, paintings and street signs. Many were inspired by other designers whose work they respected. Others were inspired by the work of fine artists or artistic movements such as "Die

Come From?

Brucke" and "Fluxus." Another commonality was the habit of collecting: Books, printed pieces, scraps of ideas from other projects, magazines, posters, Art Deco objects and cigar boxes were mentioned among many other collectibles. Several designers drew on memories from childhood, other designers drew from their education and training, while still other designers drew from travel or their reading. A number of designers rely on creativity techniques as well as visual stimuli. Several cited the importance of free association and developing lists of words, images and ideas related to the project. Sketching was also frequently mentioned as being a source of ideas and inspiration.

Creating a Lively Visual Metaphor for a Visual Library

For the Cooper-Hewitt Museum's exhibition, "A Design Resource," Drenttel Doyle Partners created a visual metaphor for the concept of a visual library utilizing huge books for the title and text panels for the show. The graphic identity was carried right out to the street via a kiosk and fence signage (the Old Style typeface is typical of that used in classic book design). Bill Drenttel felt that "The objective of this project was to pique curiosity and to delight—that's the job of the block-long signage on the fence on Fifth Avenue. The name of the show was 'A Design Resource,' and the title panels and the 'didactic panels' strike a familiar chord by resembling huge books. Of course, their objective was to inform, but we wanted to take the boredom out of it—or even better, to make things fun.

"Within the context of a design museum, the signage must not upstage the objects on exhibit but must be distinctive without being very 'design-y.' The simple metaphor of the book animates the text panels, and the simple typographic vocabulary is extended outside, now animated by scale."

**Stephen Doyle &
Bill Drenttel
Drenttel Doyle Partners**

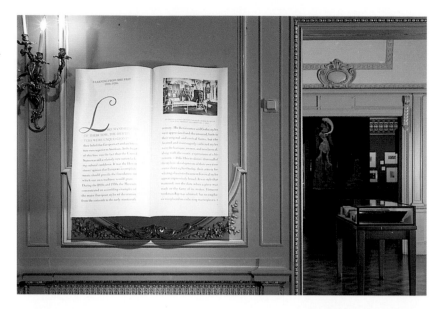

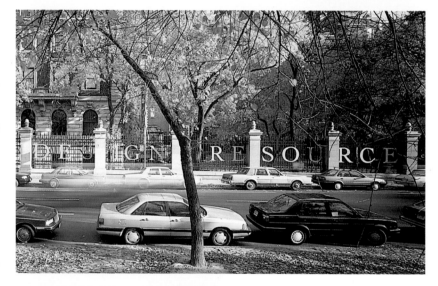

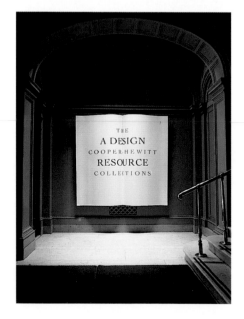

Going Beyond Literal Symbolic Imagery

"This was an exceptional project—not the sort of opportunity typically presented to a graphic designer. How often does one design a Bible? This project was composed of cover designs for four religious books in three bindings—leather, cloth with dust jackets and paperback—for the Christian Science Publishing Society.

"The church's religious principles and unique character provided the foundation for the design of the book covers, and it was a rewarding process to interpret them. Because the subject is metaphysical and spiritual in nature, literal symbolic imagery was inappropriate. Yet the books needed to establish a memorable image.

"I chose to use 'building blocks' of marble and travertine for the dust jackets and paperback covers because of the biblical reference of *petros* or *rock* in the New Testament. Christ Jesus renames Simon as Peter and declares that Peter's spirituality will form the foundation of the church. Peter or *petros* is a metaphor for this spiritual inspiration that is the rock of Christianity. Marble and granite are important materials in the neoclassical architectural vocabulary used frequently for Christian Science churches. These architectural materials convey a timelessness, permanence and subtle architectural reference.

"The warm color tones associated with light refer to inspiration and enlightenment, as does the transparency of the overlapping plane on the dust jacket."

Katherine McCoy
Cranbrook Academy
of Art

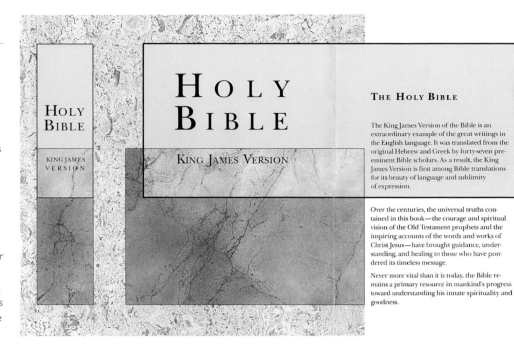

HOLY BIBLE

KING JAMES VERSION

THE HOLY BIBLE

The King James Version of the Bible is an extraordinary example of the great writings in the English language. It was translated from the original Hebrew and Greek by forty-seven pre-eminent Bible scholars. As a result, the King James Version is first among Bible translations for its beauty of language and sublimity of expression.

Over the centuries, the universal truths contained in this book—the courage and spiritual vision of the Old Testament prophets and the inspiring accounts of the words and works of Christ Jesus—have brought guidance, understanding, and healing to those who have pondered its timeless message. Never more vital than it is today, the Bible remains a primary resource in mankind's progress toward understanding his innate spirituality and goodness.

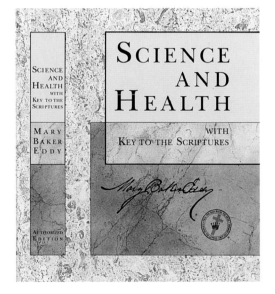

SCIENCE AND HEALTH

WITH KEY TO THE SCRIPTURES

MARY BAKER EDDY

AUTHORIZED EDITION

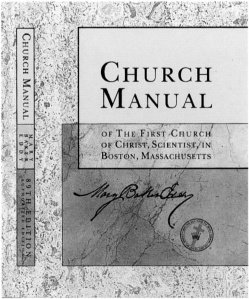

CHURCH MANUAL

OF THE FIRST CHURCH OF CHRIST, SCIENTIST, IN BOSTON, MASSACHUSETTS

MARY BAKER EDDY

89TH EDITION
AUTHORIZED EDITION

Collecting Visual Experiences for Inspiration

"I started collecting at about the age of six. When I look at my collections, it's like a visual feast. I'm mesmerized by the colors, shapes, patinas, textures and typefaces.

"In addition to the antique toys, the seed boxes, the puppets, dolls, folk art, beer labels, liquor miniatures, lid labels, tops, matchbooks and water pitchers, my walls are adorned with old magic, circus and liqueur posters. We also have over 10,000 books on art, children's fiction, photography and travel, as well as books about architecture, fashion, typography, textiles and, of course, design.

"I look at everything in our collections and use this massive assembly of eye candy as inspiration for my own designs. By exposing myself to many influences, I am constantly reminded that there isn't just one solution to a design problem.

"While designing the American Originals issue of *LAX* magazine, I was definitely inspired by the various type treatments used on many of the older packaging and labels in my collections. I viewed this assignment as an opportunity to use typography as an essential part of the design; the artwork and the articles were supplied, so my job was both to honor the illustrations and entice the reader into the text.

"I think this approach worked. Each spread has its own distinct character, much like that of my collections. The type treatment introduced the illustration and, at the same time, directed the reader to the text. I was able to build a kind of cadence that kept the pages turning, yet the magazine as a whole was very harmonious."

Mark Sackett
Sackett Design Associates

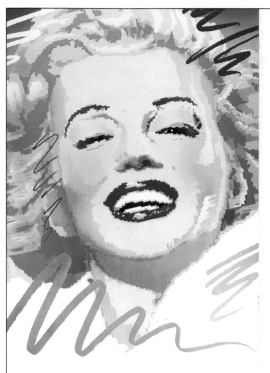

Design Inspired by All That Jazz

Sych's art, like his jazz, is a "soul thing." "If it doesn't start out as a soul-inspired experience, it defeats the true purpose of what 'art' really is. For me, design is about curiosity, enchantment and the unknown. I've found these elements on a musical level, and now I am trying to develop these same elements within the design arena."

Sych describes the parallel between his music and his designs: "If I am doing an improvisation within a structure—such as a 12- or 32-bar piece of music—I use this structure as a platform to improvise around. At the same time, in order to improvise, one must be aware that the structure contains form consisting of melody, harmony and rhythm, which can be interpreted by the artist in his or her own way." In Sych's design, the "structure" is the parameters the client gives you and the form of that structure is color, shape, texture.

According to Sych, even wrong notes in a jazz improvisation are the building blocks for spontaneous searching. As a designer, Sych embraces wrong notes, or design nuances, as an essential part of the development of an idea and establishing your own voice.

"I see beauty in things that are done imperfectly and that are not contrived. If I'm stuck for an idea, I look to the street and the signage there. Sometimes I find compassion and integrity in the sign that a guy is painting on a storefront. Often, this signage is full of life."

Paul Sych
Faith

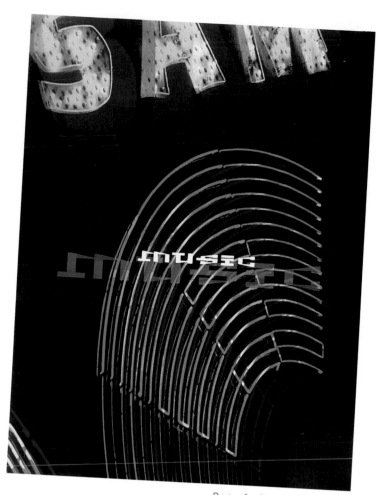

Poster for Sam the Record Man.

Title page inset design for 1994 FontShop catalog in Germany– A Love Supreme.

Ideas are everywhere for the taking—dreams, trash on the sidewalk, snippets of conversation, word etymologies, even mistakes, such as images you *thought* you saw or phrases you *thought* you heard. I try to learn from other designers, but I try not to be influenced by them, otherwise everything starts to look the same, which is rather dull. Duchamp said, 'I felt that as a painter it was much better to be influenced by a writer than by another painter.' "

When exploring ideas, "I try to think rationally as well as associatively. Asso-

Mark Fox
BlackDog

ciative thought is random and more unconscious, and it allows for the unrestrained freedom that I find necessary for creative work. The logo for Jan Collier stemmed from an unconscious association: I started drawing, and for some reason, I kept drawing a skull and a heart balanced on a fulcrum. Upon inspection this seemed a perfect metaphor for art representation. I wrote in my sketchbook:

Balance

Love, Hate

No Money, Money

Art, Commerce

"Later I came across the industrial symbol for balance, that is, the center of gravity, that I pasted in my sketchbook. I must have seen this symbol at some point before I started Jan's logo, but I certainly wasn't thinking of it consciously at the time. Because I specialize in logos and

icons, I have a lot of books on symbolism. The symbol for balance that I pasted in my sketchbook was from Henry Dreyfuss's *Symbol Sourcebook*. Two other favorites are both volumes of Leslie Cabarga's *A Treasury of German Trademarks* and J.C. Cooper's *An Illustrated Encyclopedia of Traditional Symbols*.

"Extensive research for this project wasn't necessary because I know Jan and her business. I usually do try to find out what a client's assumptions are and what they like and dislike in my work. The trick is to get enough information to start designing but not so much that it paralyzes you. Some degree of ignorance is not always a bad thing. Without volumes of oppressive 'research,' you are free to explore and free to create.

"Normally I show ideas in both tight and rough form, depending upon what seems appropriate or necessary. In Jan's case, I showed her tight sketches that I had inked and photocopied. I proposed that she use four different logos on her letterhead, envelope, business card and mailing label. She ultimately chose only one of the four. It wasn't necessary to convince Jan to accept this logo. I don't think I have ever convinced a client to accept an idea. Rather, they can see for themselves if my work is good or appropriate for them. It was apparent to both Jan and me that we had a good mark. It then became a matter of fine-tuning it. Jan thought the mark was too hard and that it should be softened somehow to fit her personality better. I decided to 'distress' the original mark, and she loved it. If it hadn't been for Jan, the logo wouldn't have gone through this transformation, and it would be less interesting."

Mark Fox fills his sketchbooks with "ephemera, dreams, observations, and sketches for jobs real and imagined." He uses words and pictures to associatively explore ideas.

Jan Collíer

jan Collier

Jan Collier

Jan Collier

He experimented with several typefaces before settling on Dolmen. He did modify the letter *J* to make it more legible.

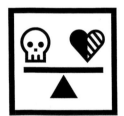

For the Jan Collier logo, he developed four logos based upon drawn and found images in his sketchbooks. Although he initially suggested using each of the logos on a different component of the stationery system, Collier chose to go with only one.

Jan Collíer

The logo Collier chose (©1993, 1994 Mark Fox/BlackDog).

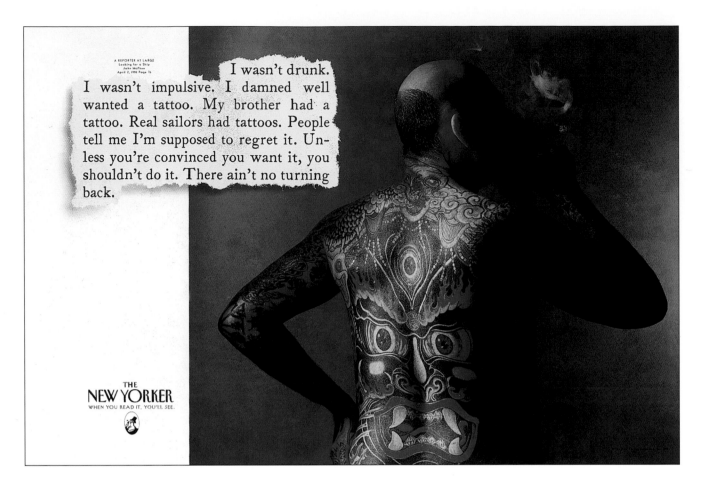

A REPORTER AT LARGE
Looking for a Ship
John McPhee
April 2, 1990 Page 76

I wasn't drunk.
I wasn't impulsive. I damned well wanted a tattoo. My brother had a tattoo. Real sailors had tattoos. People tell me I'm supposed to regret it. Unless you're convinced you want it, you shouldn't do it. There ain't no turning back.

THE
NEW YORKER
WHEN YOU READ IT, YOU'LL SEE.

Taking the Initiative to Solve a Problem

"The difficulty with this project was that the editorial staff of *The New Yorker* couldn't agree on anything that we wanted to say about them. So we decided to allow the magazine to speak for itself by simply featuring excerpts ripped from the pages. We also cheated and answered one of the most common complaints about the magazine—that there were no pictures. We used one in every ad."

**Jeffrey Goodby
Goodby, Berlin &
Silverstein**

Inspired by a Childhood Memory

"The idea for 'Young Riders' was inspired by an old photo of my brother and me when we were younger, dressed up in kiddie cowboy attire. For this project, I sent letters to Texas celebrities and personalities asking if they would send us snapshots of when they were younger dressed up like cowboys. We also researched and found photos of historical figures dressed up as kiddie cowpokes. I discovered that almost everyone of my generation or older had been photographed this way at some point growing up in Texas."

D.J. Stout
Texas Monthly

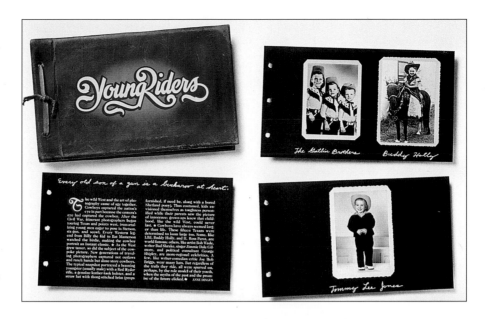

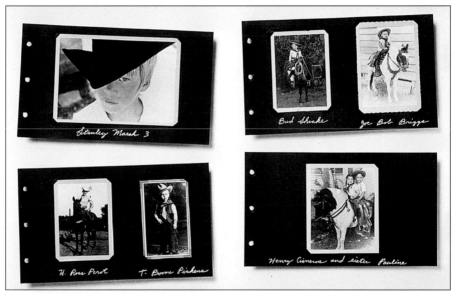

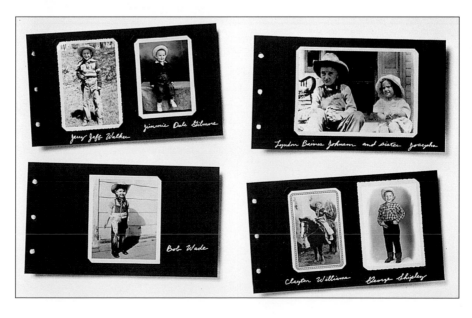

In this case, the piece could not have been created if I had not done my homework. It was created as a general information piece that would be used by the National Museum of the American Indian in a variety of ways. The first thing that I did was to immerse myself in reading. I talked to a lot of the staff and curators. Perhaps one of the most important pieces that I read was the architectural program written by Robert Venturi and Denise Scott Brown. This piece synthesized a lot of what I had been reading. It pulled an awful lot of the literature together and started to give form to some of the concepts I was playing with.

**Judy Kirpich
Grafik Communications,
Ltd.**

"Initially, I worked very closely with the Director of Publications, Gaye Brown. We talked about different ways that we could express the 'rebirth' of this museum. We discussed using a variety of myths and fables, thought about using the creation myth in some form, and discussed the importance of the elements and the four ordinals in native culture. We also discussed the political problems of showcasing one region over the other and the necessity of avoiding any triteness in the production of this piece. We also talked about the importance of context and how important it is vis-à-vis ceremonial objects.

"All the while, I learned all I could about Native American traditions and the diversity of the culture. In addition to reading, I listened to Native News on Pacifica Radio, viewed videos that the museum was producing, and shed as many of the Anglo misconceptions as I could.

"Initially I presented Gaye Brown with two different conceptual ways to approach the brochure. I wanted to get a sign-off on one direction before I developed a design per se. We agreed that we would pursue a direction that dealt with the elements—earth, water, sky and fire—and that we would use a square format and contrast object to environment.

"I began with very rough quarter-size sketches. Once a direction was approved, we moved up to full-size comps using stock photos to illustrate the types of photos and images we were looking for.

"We began to look at different images of the elements and contrast them to objects within the museum's collection that would not only be seen in context to the element but would represent the diversity of the collection. It was decided from the beginning of this project that we would use native photographers whenever possible. No amount of reading could compensate for the fact that we were not Native Americans, but the close collaboration between our staff and the museum staff made up for that deficiency.

"Working with a native photographer was critical for a number of reasons. Walter Bigbee was able to add immeasurably to the content of our photos. He suggested that we substitute sweet grass, a ceremonial object, for regular saw grass in one image and advised us on the importance of smoke in shooting our fire photos. We had thought it would be a rather easy task to get eagle feathers from either a zoo or the park service. Not! It seems that these feathers are reserved only for natives. Walter Bigbee was eventually able to secure the feathers for that shoot."

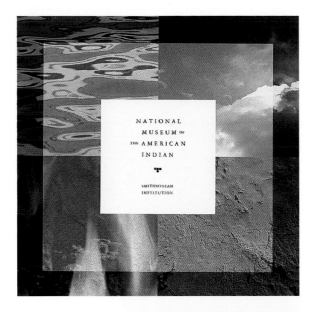

NATIONAL
MUSEUM OF
THE AMERICAN
INDIAN

🔳

SMITHSONIAN
INSTITUTION

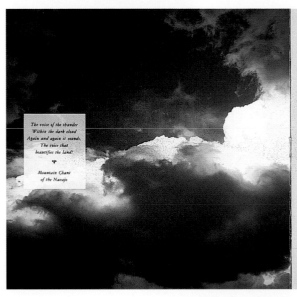

The voice of the thunder
Within the dark cloud
Again and again it sounds,
The voice that
beautifies the land!

🔳

Mountain Chant
of the Navajo

THE NATIONAL MUSEUM OF THE AMERICAN INDIAN, ESTABLISHED BY AN
ACT OF CONGRESS IN 1989, IS DEDICATED TO THE PRESERVATION, STUDY, AND
EXHIBITION OF THE LIFE, LANGUAGES, LITERATURE, HISTORY, AND ARTS OF
NATIVE AMERICANS. PART OF THE SMITHSONIAN INSTITUTION, THE MUSEUM
IS WORKING IN COLLABORATION WITH THE INDIGENOUS PEOPLES OF THE
AMERICAS TO PROTECT AND FOSTER NATIVE CULTURES THROUGHOUT THE
WESTERN HEMISPHERE. 🔳 CURRENTLY, THE NATIONAL MUSEUM OF THE
AMERICAN INDIAN HAS ADMINISTRATIVE OFFICES IN WASHINGTON, D.C., AND
EXHIBITION GALLERIES IN NEW YORK CITY. A RESEARCH BRANCH, LOCATED
IN THE BRONX, NEW YORK, HOUSES CURATORIAL OFFICES AND THE BULK OF
THE MUSEUM'S ONE MILLION OBJECTS. CONSIDERED ONE OF THE WORLD'S
FINEST AND MOST COMPREHENSIVE ASSEMBLAGES OF INDIAN ARTIFACTS, THE

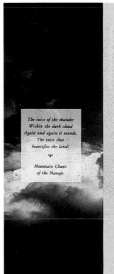

The voice of the thunder
Within the dark cloud
Again and again it sounds,
The voice that
beautifies the land!

🔳

Mountain Chant
of the Navajo

COLLECTION SPANS 10,000 YEARS OF NATIVE HERITAGE. APPROXIMATELY 70
PERCENT OF THE HOLDINGS REPRESENT INDIAN CULTURES OF NORTH AMERICA,
30 PERCENT CENTRAL AND SOUTH AMERICA. 🔳 THE MUSEUM'S FILM AND
VIDEO CENTER PROVIDES INFORMATION ABOUT FILMS REGARDING NATIVE
PEOPLES TO CULTURAL ORGANIZATIONS, TRIBAL COMMUNITIES, EDUCATORS,
AND THE GENERAL PUBLIC. THE CENTER HOUSES A STUDY COLLECTION OF
RECENT WORKS BY INDEPENDENT AND NATIVE AMERICAN FILMMAKERS, AS
WELL AS FILMS PRODUCED BY CANADA'S NATIONAL FILM BOARD AND MEXICO'S
INSTITUTO NACIONAL INDIGENISTA. IN ADDITION, THE CENTER ORGANIZES
PUBLIC PROGRAMS, INCLUDING A BI-ANNUAL FILM FESTIVAL IN NEW YORK
CITY AND INTERNATIONAL TRAVELING FESTIVALS.

Exploring Diverse Avenues for Ideas

"My first step in the design process is to look at the task and define the message. After this I compile a list of elements and break those elements into distinct categories, rarely more than three, that relate to the idea to be communicated. Every detail is important because many times the best idea is conceived from one key element. From these categories come different scenarios, or initial concepts. The key is to constantly cross-compare the elements within these categories.

"This process works better and faster if I continue to explore diverse avenues of communication, such as artistic techniques, word relationships, visual shapes, art history, photographic techniques, architecture, nature and so on. Keeping true to a less-is-more philosophy usually provides the best landscape for ideas to reveal themselves, with execution left to make a more personal statement.

"I also listen to my client because he is the closest person to the product or service and often has terrific ideas, even though he might not even realize it. When the client comments or proffers an idea, the designer must have a clear and exact answer, especially if it is contrary to the client's opinion. This is where the most controversial word enters the design process—compromise. Many designers just can't handle it. But I find the more honest you are, the more able you are to recognize a positive idea and refute a bad one."

John Norman
NIKE, Inc.

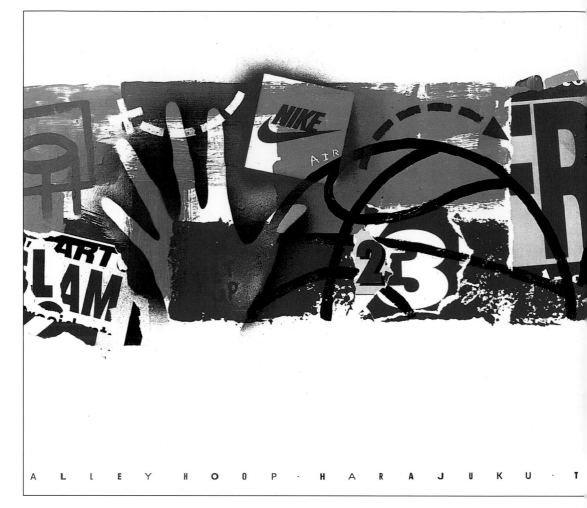

ALLEY HOOP · HARAJUKU · T

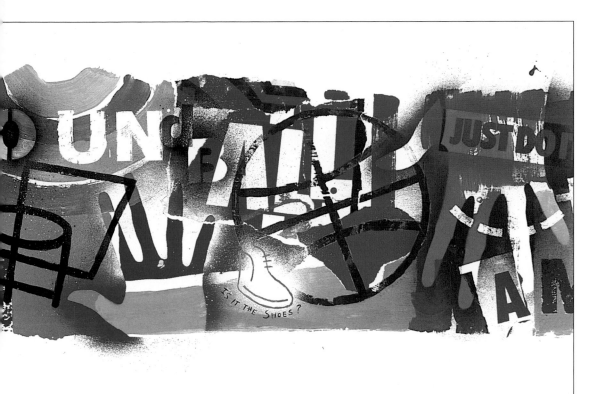

K Y O · J A P A N · A P R I L · 2 7 , 1 9 9 3

Finding Ideas by Listening

"Ideas come from life. They're all there stockpiled for reference. Everyone has memories, emotions, thoughts, insights and perspectives that need to be focused to solve a problem or to demonstrate a concept. Ideas come from this process of focusing.

"The key to finding ideas is to listen. A good listener hears all sides of a story—information must be gathered on the competition as well as on your client. We gather information by looking for emotional responses and insights into subjects from real consumers. We look for honesty. There is no salvation for delivering to your client only what they want to hear. The most powerful design is honest.

"Questioning the norm is critical to producing distinctive design. Although we have used traditional focus group techniques, we question their effectiveness. What we call 'mother-in-law' research has been more useful, wherein we talk to people directly and honestly in a relaxed environment—our studio after hours, someone's home, on the street, in a park or a restaurant. We talk to sales representatives, consumers, dealers, kids. We use our friends and associates around the world to do the same. We can gather information and attitudes worldwide in a week's time. This delivers a serious reality check on any topic. Many times, we videotape—just hand-held stuff—to document responses and environments, then we produce a funky raw video that allows the client to look directly into the heart of the issue."

Michael Jager
Jager DiPaola Kemp

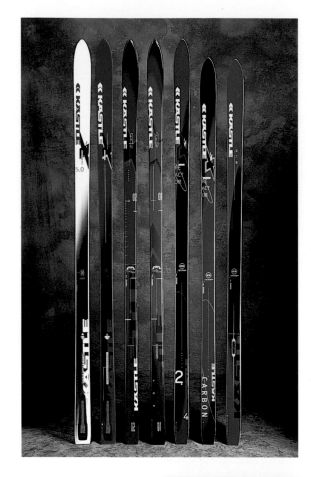

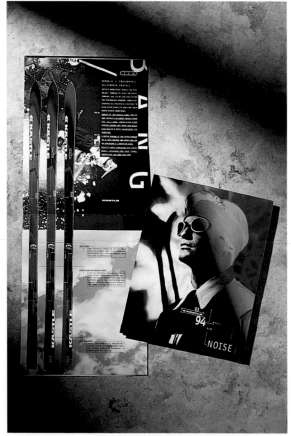

Inspiration From Within the Project

"The idea for this poster grew directly from the fact that the theses of five masters of art students were being exhibited. I immediately thought of a hand image and five fingers. Since the hand is universally recognized as a symbol of art, creation, etc., I asked myself how I could make it work for this project.

"My solution was simple. Clemson University used to be strictly an agricultural/engineering college, so the use of soil was at the top of my mind. The dirt creates a visually striking texture. Visualizing the dirt and the hand made it all come together to create the impression of the first artist who put his handprint on cave walls and the impression that these five masters artists may make on the world. The photographic lighting creates an optical illusion: Is the hand coming out of the earth or going into it?

"My choice of type was meant to create the 'farmer's co-op' feeling. I used Old Futura Black in different sizes, as if this was a meeting poster for the Future Farmers of America."

Gil Shuler
Gil Shuler Graphic Design, Inc.

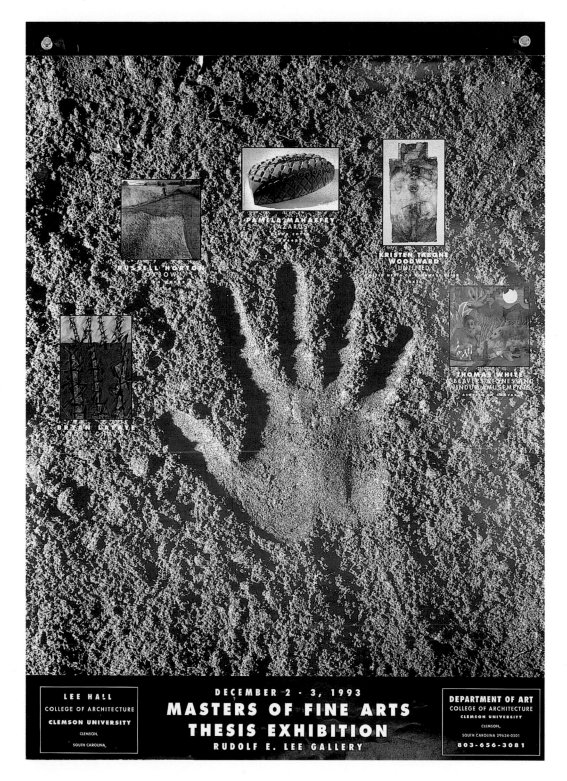

Nemzoff/Roth Touring Artists is a new company composed of two seasoned performance-art booking agents. They joined forces so they could expand beyond their narrow, individual regions of Seattle and San Francisco and go national. They hired me to design a piece that would draw attention to their artist roster and establish them as a new force on the block.

"My clients' competition used a singularly earnest, yet unexciting, standard of poorly done, computer-generated design. With this in mind, I felt my clients could blow the competition out of the water without resorting to shock tactics. My goal was to create the graphic equivalent to my clients standing up and stating firmly, 'Hey look at this! It's great, it's fun and we're new!' without being gaudy and tactless.

"I wanted the promotional piece to be stark and bold, emotive and powerful, and the color affordable and in sharp contrast to the competition. I chose black and white to accomplish these two goals. The imagery needed to be made as big and provocative as possible, yet tasteful.

"For inspiration, I referred to a piece designed in the mid-eighties by the late Wes Anderson (former art director of the

Art Chantry
Art Chantry Design

Village Voice). It was printed on newsprint as a promotional device for a local performance art series for an organization called On The Boards. It consisted of a broadsheet-style newspaper with each page acting as an ad for each performer of the season. I adapted the basic concept and simply made each page a miniposter for each of my clients' artists. The final design was also usable as a stock poster design for the locations that booked the artists.

"The aesthetics of this design has worked well in Seattle, where my studio is. There, the look is attached to performance art. It's like the 'punk' ethic, which tries to scare people away and, ultimately, attract people who understand the art, speak the same language, and will come and enjoy the performance."

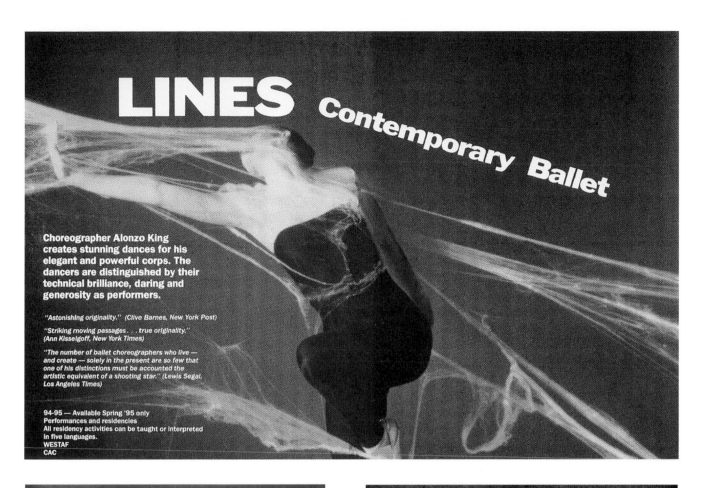

LINES Contemporary Ballet

Choreographer Alonzo King creates stunning dances for his elegant and powerful corps. The dancers are distinguished by their technical brilliance, daring and generosity as performers.

"Astonishing originality." (Clive Barnes, New York Post)

"Striking moving passages. . . true originality." (Ann Kisselgoff, New York Times)

"The number of ballet choreographers who live — and create — solely in the present are so few that one of his distinctions must be accounted the artistic equivalent of a shooting star." (Lewis Segal, Los Angeles Times)

94-95 — Available Spring '95 only
Performances and residencies
All residency activities can be taught or interpreted in five languages.
WESTAF
CAC

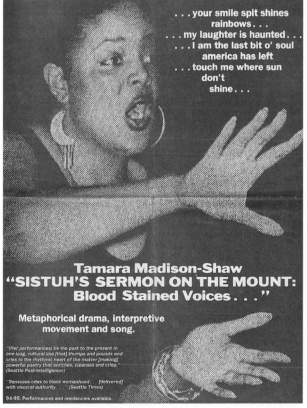

. . .your smile spit shines rainbows. . .
. . .my laughter is haunted. . .
. . .I am the last bit o' soul america has left
. . .touch me where sun don't shine . . .

Tamara Madison-Shaw
"SISTUH'S SERMON ON THE MOUNT: Blood Stained Voices . . ."

Metaphorical drama, interpretive movement and song.

"(Her performances) tie the past to the present in one long, cultural line [that] thumps and pounds and cries to the rhythmic heart of the matter [making] powerful poetry that enriches, cleanses and cries." (Seattle Post-Intelligencer)

"Sensuous odes to black womanhood. . . [delivered] with visceral authority. . ." (Seattle Times)

94-95: Performances and residencies available.

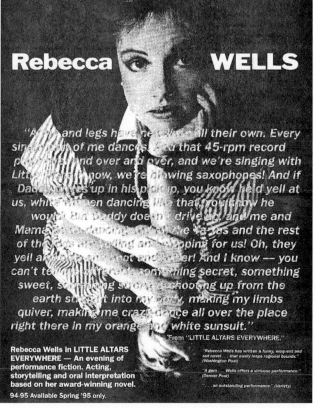

Rebecca WELLS

"Arms and legs have lives all their own. Every single inch of me dances. And that 45-rpm record playing over and over, and we're singing with Little Richard now, we're blowing saxophones! And if Daddy drives up in his pickup, you know he'd yell at us, white women dancing like that, you know he would. But Daddy doesn't drive up, and me and Mama just keep dancing. Oh, all the Ya-Yas and the rest of them are yelling and clapping for us! Oh, they yell and clap, foot and holler! And I know — you can't tell anybody, it's something secret, something sweet, something strong, shooting up from the earth straight into my body, making my limbs quiver, making me crazy, dance all over the place right there in my orange and white sunsuit." From "LITTLE ALTARS EVERYWHERE."

Rebecca Wells in LITTLE ALTARS EVERYWHERE — An evening of performance fiction. Acting, storytelling and oral interpretation based on her award-winning novel.
94-95 Available Spring '95 only.

"Rebecca Wells has written a funny, eloquent and sad novel. . . that easily leaps regional bounds." (Washington Post)

"A gem. . . . Wells offers a virtuoso performance." (Denver Post)

". . . an outstanding performance." (Variety)

One Studio, Many Approaches to Creativity

"For me design is problem solving and analysis. It's using whatever creativity I possess to solve my client's communication problem. I use information gathering, which dictates direction. There are also practical considerations, such as format and budget. From here I develop the parameters and questions. Basically, the process is information gathering, synthesis, analysis and solution. I gather information from my client and from the industry: What are the standards? What are other similar companies doing? What is being done in the field establishes the playing ground.

"The theme of the 1992 report for Toronto-Dominion Bank was the accessibility of the bank's services. Kim LaFave's illustration style, chosen for its friendliness, warmth and humor, spoke to the quality of the bank's services, rather than to the austere pinstripe notion of banking.

"It's hard in corporate design to be creative and break new ground. There are a few people who do this—Jim Berte, John Van Dyke, Pentagram—and their work inspires me. They give me hope that there are more solutions that haven't been done. I try to bring that same kind of focus, energy and thought into what we do and not go for trite and staid."

**Roslyn Eskind
Eskind Waddell**

Toronto-Dominion Bank Annual Report, 1992. Cover and Interior Spread: Roslyn Eskind.

"After a briefing from the client, I immediately see images or develop a feeling for the project. I often write lists of thoughts or images or draw small icons that relate to the topic. After making as many connections as possible with the topic, I begin to compose the elements. These early thoughts and images eventually provide clues for the use of color and typography to further convey the mood.

"For the London Insurance Group project the topic was real people since people are the most important aspect of the insurance business. I felt that the entire approach should be warm and friendly. The colors were kept soft, and the photography, which was very honest and approachable, was layered to achieve a dreamlike effect."

Donna Gedeon
Eskind Waddell

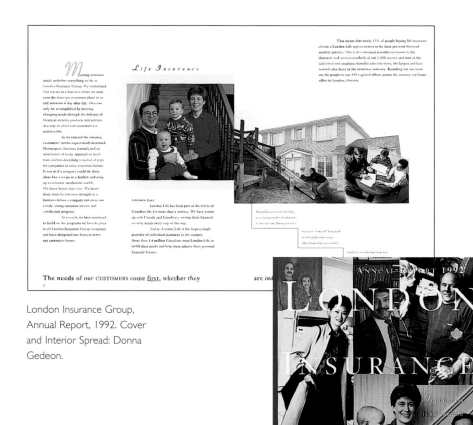

London Insurance Group, Annual Report, 1992. Cover and Interior Spread: Donna Gedeon.

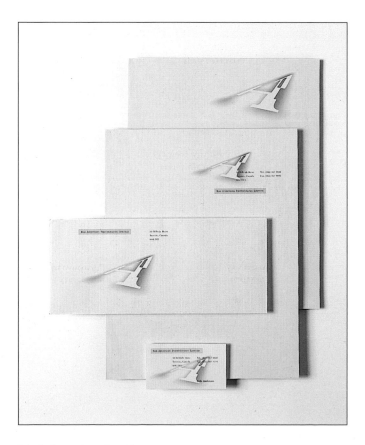

Bob Anderson Letterhead System.

Computer technology was a key tool in the design of this letterhead system for Canadian photographer Bob Anderson. Armed with only one requirement—that her design incorporate the letter *A*—the designer began an extensive exploration process on the computer. Her goal was to communicate a sense of light and the illusion it can create.

Lyon began by exploring some ten different typefaces, and through the use of Photo-Shop, she combined elements of four of the faces. She ultimately designed twenty differ-ent *A*s. From these she culled certain elements that she liked and combined them into one letterform. She recomposed the *A* so it didn't resemble itself until the cast shadow was added. The only problem was the tendency for the letter-forms to resemble *H*s because they lacked enough of the inherent *A* characteristics. The skewed angle of the final design emphasizes the light falling on the letterform, while subduing the directness of the letter.

Nicola Lyon
Eskind Waddell

Idea Intersection

"Our paper promotions set out first to address a specific paper message and second to engage the audience in a visually interesting, well-written story. Anything less is self-absorption.

"Everything can be considered a resource. I encourage designers to forage their environments for ideas: in conversations, samples, photos of travel, or visits to the stripmall. A good designer is a visual scavenger. The world is his attic.

"Ideas then must intersect; the client's needs, the writer's words and the designer's imagery together make an effective solution. If you do not meet the criteria of the client, you're not solving a communication problem. If you do not heed the written word, your imagery will be superfluous. If you cannot translate verbal language into visual language, you're not a designer. All three perspectives must work together.

"Our concepts develop from the spoken word—what the client tells us—to the written word—how the writer processes that information—to the visual word—how the designer processes what the writer supplies. We pour out all ideas, sift and sort, gathering input from the client along the way. It is not a black box—some magical thing—it is hard work and open discussion. We have found that the more we involve the client in this process, the more successful the work is. A good client supplies ideas all the time."

Robert Wages
Wages Graphic Design

My Many Sources for Ideas

"The first thing you need is confidence," explains Nancy Skolos. "One technique I use when I feel insecure about designing a new project is to look at projects I've done in the past. I say to myself, 'You did that so you can certainly do this.' It sounds like something out of a self-help book, but it's something I've done ever since I started design school.

"Another thing is to think about the problem a lot before you start to sketch, even though it's hard to make clients understand how important time is to the creative process.

"A lot of really good ideas are rejected by clients. So we save them in a drawer and recycle them when it's appropriate. It helps to have a backlog of good visual concepts because it is hard to be creative on command.

"I try to avoid starting with a blank sheet of paper. One thing we do is keep a backlog of cut paper compositions. We have several 'magic' color paper drawers that randomly produce interesting piles of positive and negative shapes. When one appears, we tape it down and save it.

"So far I've only discussed visual ideas. Another important aspect is developing the communication concepts. Often we make long lists of shapes, symbols and words that deal with a subject. This gives us a much broader base of potential imagery to choose from."

Nancy Ann Skolos & Thomas Wedell Skolos/Wedell, Inc.

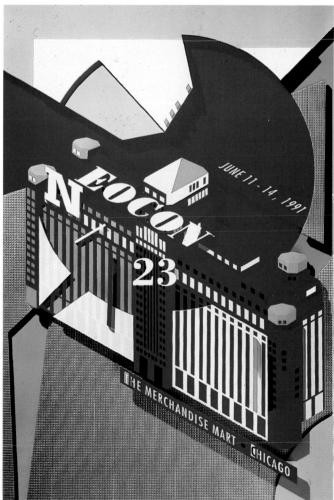

From a "magic" color paper drawer, Nancy Skolos chose a piece of cut paper that became part of the conceptual background to this poster.

Since I started as a designer in 1953, I have never seen the difference between illustration and graphic design. It seemed to me, then, that it would be far better if I could do both myself, so I could put them in the context I wanted. I always thought of myself as somebody involved in the world of design who could handle the complete job, which is to say figure out the imagery, draw the imagery, figure out the typography, do the typography, arrange the layout, figure out the colors and so on. I didn't want to be an orchestrator of other people's work. The way to avoid that was to be competent in doing it all myself.

Milton Glaser
Milton Glaser, Inc.

"In the beginning I was excited by the idea of demonstrating what I knew and finding out what I didn't know. What happens as a beginner is there is very little that you really understand, and so, out of the fear and excitement of a truly novel experience, you develop an interest in the subject, which disappears after you develop some mastery. At the beginning everything is exciting and frightening and challenging. There is still nothing that thrills me as much as making a visual discovery that communicates clearly. To do a drawing that I think is a good drawing or a typographical exercise that looks fresh and is distinctive—those things have not diminished. They have intensified.

"I find inspiration through my interests and the many different manifestations of the visual arts, art history, primitive culture, contemporary work. I've never thought that any one moment in history or any one style was the reservoir of truth. My work has always been derivative in the sense that I have always looked at everything. When I was in Italy, I learned to love the Renaissance, as well as the baroque, as well as the Roman, as well as Etruscan, as well as contemporary work. It all seemed to me to form a rich continuum. I think that design is about understanding that history and working within the framework of that history.

"Like all people, I run into periods where I feel more inspired than others, particularly when I'm doing work that I'm not interested in. Sometimes you get a lot of jobs that aren't of compelling interest— they are not demanding enough or you have done them before. The real problem is like simulating excitement in sex; you have to fool yourself. You have to let the process of work reengender your enthusiasm. You have to differentiate the nature of the assignment, the expectation of what is asked for, from your own possibilities so that you can reinvest your energy.

"When I am not designing, I travel and I spend a lot of time reading. I think about design as a manifestation of philosophy, which is the role that painting has taken over. Painting is more about philosophy than about painting objects. One might say the same about design, which has the same function in a culture, which is about a view of truth that is manifested in a graphic object. I think when you are looking at things like that you think about your work differently, and it gives you a new position to work out of. When you are thinking only of servicing people, in terms of providing an answer to a problem they have about selling goods, it's a little more difficult.

"The field itself is not a great source

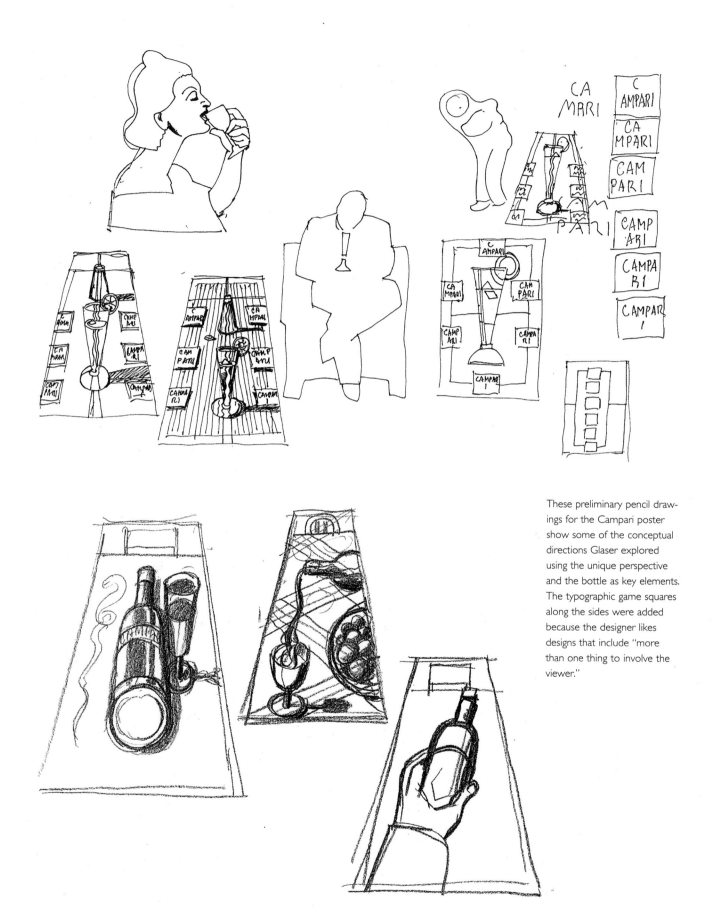

These preliminary pencil drawings for the Campari poster show some of the conceptual directions Glaser explored using the unique perspective and the bottle as key elements. The typographic game squares along the sides were added because the designer likes designs that include "more than one thing to involve the viewer."

of ideas. In the course of looking for ideas about what graphic design might be, you have to reach for other resources or else your work gets stale and overly related to what is going on. Because design is a vernacular language, you have to speak the language that is being spoken, but you can get stuck in the fashion aspect of design, which is the part that changes most readily and perhaps is the least enduring.

"For many years, the most significant relationship was between art and design, which meant that you were conscious of what went on or what preceded you in the world of art. Many ideas in graphic design had their origins in surrealism or in Dada or in the artistic movements of Modernism. By virtue of that, those ideas informed graphic ideas as much as a half century later.

"Sometimes, you can look at nature as a source of ideas—the way a shadow falls across the path can be as much an inspiration for how to solve a design problem as the current annual. I also get interested in obsessive ideas that stay with me short term. A current interest might be an idea about perspective or space or color, which I get seized by and follow for a while. Ideas turn up because in every problem the heart of the solution is embedded in the problem like a piece of gold in a matrix of rock. What you learn to recognize, and one of the most thrilling things about design, is that every problem fundamentally will guide you to the solution if you believe that the problem and solution are bound in that way. The whole joy of graphic design is discovering within the problem the answer and trying to sniff out the gold."

In 1992, the Italian-based Campari company sponsored a Milan exhibition of Milton Glaser's work and commissioned him to create two advertising posters for their product, Campari Soda.

"Campari is well known for its great tradition and history of poster art and for commissioning graphic designers to do posters featuring Campari products," Glaser explained. "Most of the past poster designs have been based upon the product itself, and I decided to continue that tradition. My guiding principles throughout the process were the shape of the bottle and the idea of perspective.

"I was interested in doing a non-square poster and in using the cut of the poster as a means of expressing perspective. I've done several like that. With Campari, the shape of the bottle started the process. The idea of perspective was already in my mind, and I saw that the shape of the bottle could be reiterated by the shape of the poster and that the shape of the poster would then become an exercise in perspective. The dialectic between something that did not decrease in size and something that did and that both have the same characteristics is a little internal joke in that poster. The form suggests that with the same form you can represent two physical occurrences, one where the object basically has a shape that suggests something and one in which the effect of perspective produces the shape. That kind of game was undoubtedly the way my unconscious worked on the problem.

"Ideas that persist in the memory go on recurring all through your life in some peculiar way. So, certain images and ideas come up over and over again. But you take a new slant on the same content. I can see ideas that I think are fresh now have their roots in something that occurred when I was twelve years old. You actually recycle a lot of internal material and try to improve on it or change it. And, occasionally, you have new insight for treating things the way you haven't done before."

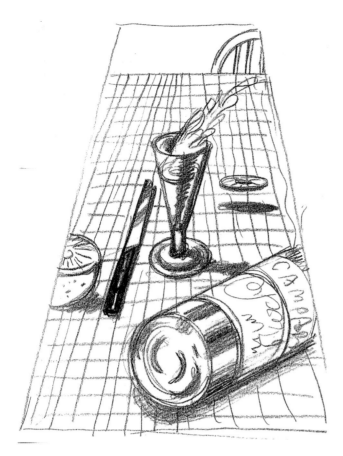

More detailed conceptual drawings.

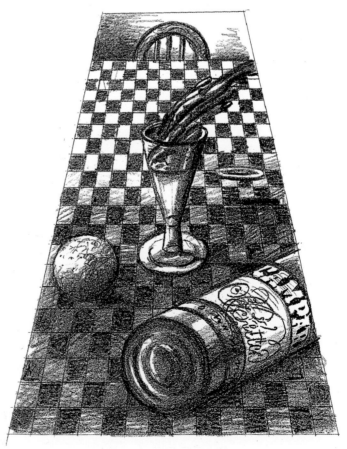

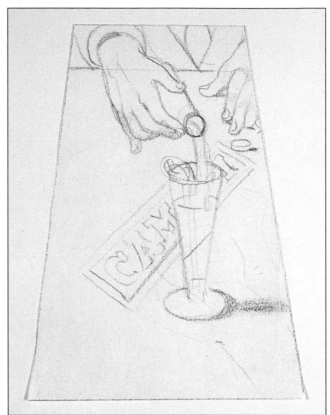

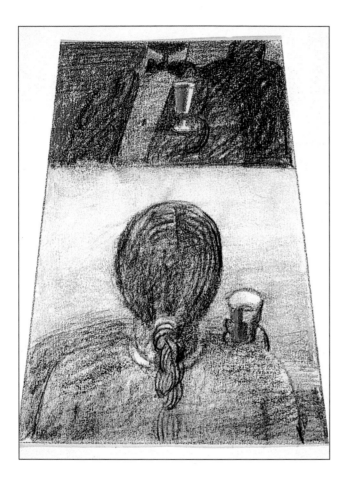

Color studies followed the
pencil drawings. The vivid
color palette was chosen to
coordinate with the assertive-
ness of the product's bright
red color.

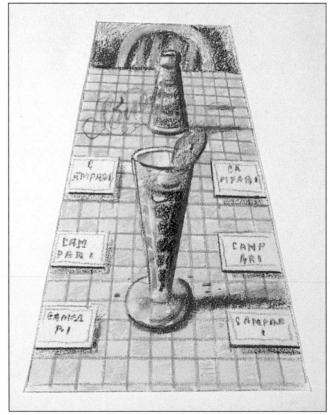

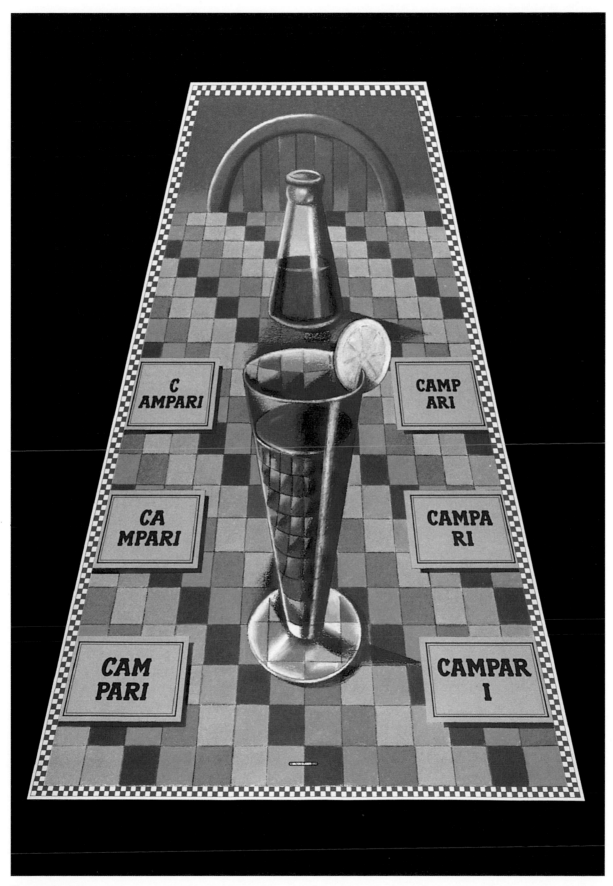

The actual poster.

Uniqueness Is the Key to Good Design

"Every design should be unique. If you hire a designer to do something and you can predict what the design will look like, then I don't think this person is a good designer. A design should surprise and enlighten; it should tell the viewer something he doesn't already know. I don't like predictability in design.

"My teachers at Penn State felt strongly about uniqueness in design, about finding your own voice. There was no unified look there, no visual agenda. I learn what to do next by doing something that's different from what's been done. I find English designer Peter Saville's work inspiring because it is unpredictable. Each job is a point at which he reinvents himself."

The *Darling* cover is an excellent example of Kidd's approach. Both the spine and front cover are visually intriguing. The illustrative elements on the cover are literal depictions of the book's contents, which tell the story of two young brothers' love for a cow named Darling. "When you first see this cover, it doesn't make sense," Kidd notes. "But after reading the flap content, you get it."

Come to Me is a collection of stories, some of which are funny while others are disturbing. "This cover is more open to interpretation. The design was far more intuitive. While it creates a sense of home and domesticity, turning the chair sideways says there's trouble in domesticity."

Chip Kidd
Random House

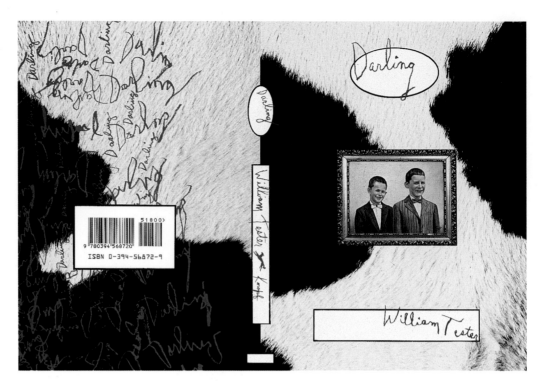

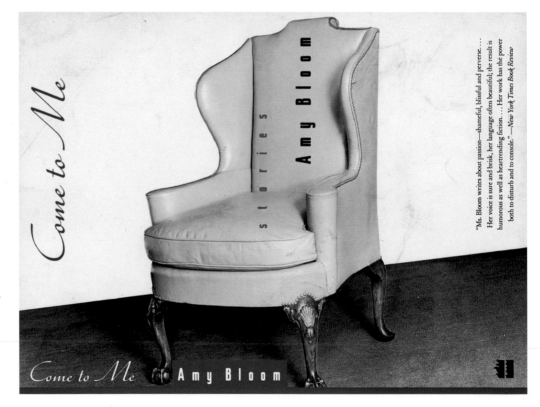

"Tieing" Up a Great Idea

While growing up in South Africa, and later as a young designer, Rod Dyer always read American magazines. As a child, Dyer was especially attracted to the ads, and through these he fell in love with American ties.

"I always loved ties. As a kid I used to buy them for only a dollar fifty, but sometimes two or three dollars. When I moved to New York City in 1957, I found them in antique shops and started collecting them. In 1985 I approached Abbeville Press with the idea of doing a book on vintage ties."

With his personal collection of 200 ties as a start, he began visiting antique shops looking for vintage tie collectors. By chance, tie collector Ron Sparks (who owns 3,000 ties) visited one of these shops the day after Dyer had. The store owner put Sparks in contact with the designer, and the two decided to undertake the book project together. The most difficult part of the project was getting the ties, organizing them, and making sure the right ties got back to the right owners.

Unlike in most author-publisher agreements, Dyer got the green light to design the book himself and to prepare camera-ready mechanicals (a monumental and expensive undertaking). Only vintage line and halftone art and studio shots of the tie collections were used to illustrate the book, which is now in its third printing.

**Rod Dyer
Rod Dyer Group, Inc.**

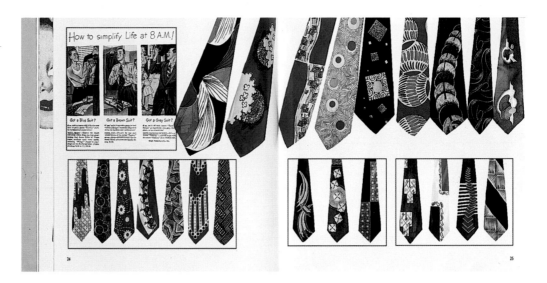

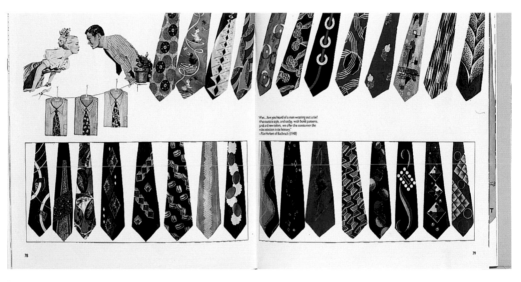

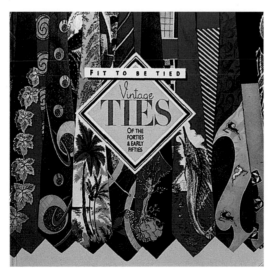

Modern Dog is composed of four individuals whose efforts blend perfectly in collaboration. Robynne Raye explains, "We never assign jobs. We meet with a client together, work on the project individually but at the same time, then show our solutions to the client. Usually the client mixes portions of all of our solutions."

In Raye's opinion, the advantage to this process is that the client "ends up with a better product. And we think clients like it because they know they'll get at least four directions and more for their money."

Raye describes why she thinks the collaboration works: "I'm with three people I really respect and whose work I admire. There are no art directors here. And no matter how absurd a comment or idea is, we try not to put it down. We tend to bounce things off each other." According to Michael Strassburger, "The advantage to me of collaborating is that I have three more sets of eyes that I trust. Sometimes I can get into a project hard-core and lose myself and my perspective."

When a studio works so smoothly, it's easy to forget that the designers are still individuals, with unique perspectives, processes and strengths.

Robynne describes her work as having "a real naive and unsophisticated quality that early on I tried to battle. One day I decided that it was OK to have flaws. I've learned not to become anal about flaws. So, instead of fighting it, I went with it, and this philosophy became the studio philosophy." The type on the "Capitol Offense" piece was an accident that she saw as a good design solution. She used a primitive coloring method called Omnichrome—colored plastic film that when heated transfers the color to the toner of a photocopy or a laser print. "The color smudged and smeared, which suited the cartoon."

Michael Strassburger believes that one of his primary contributions to the collaborative process is "a variety of design styles. I am comfortable doing all kinds of styles, such as the twenties or fifties era, hand-done or computer art. When I get a project, the design style I choose may not be attractive to me personally, but I feel good when it obviously solves the problem." When designing the *Satisfied Mind* album cover, Strassburger knew instinctively that he wanted it to look like an old folk or blues album. He likes the design because it is "something that doesn't need to be explained."

When Vittorio Costarella goes off into a corner to develop ideas he first does a lot of sketching. "When I'm sketching, my mind is like a pinball machine with ideas just popping out. Often the title of the project, such as a poster, gives me ideas that I play off. I think of the obvious solution to clean my head, then I look for different angles. I look for abstract solutions, probably because my dad is an abstract painter. I'm also pretty cheap, and so I look for ways to recycle things. I often use materials at hand, which generates a style that is different in the studio." To interpret jazz for the "Jazz Masters" ad, Vittorio Costarella created an illustration influenced by the art of Ben Shawn.

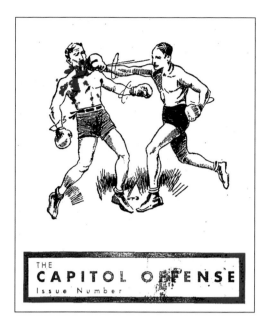

Capitol Offense, Robynne Raye.

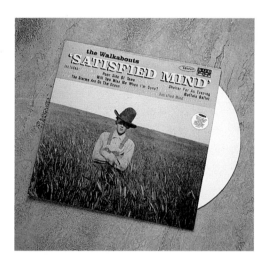

Satisfied Mind, Michael Strassburger.

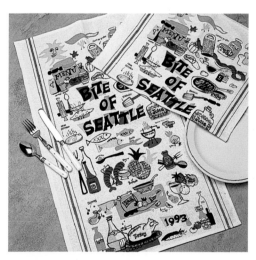

Jazz Masters, Vittorio Costarella.

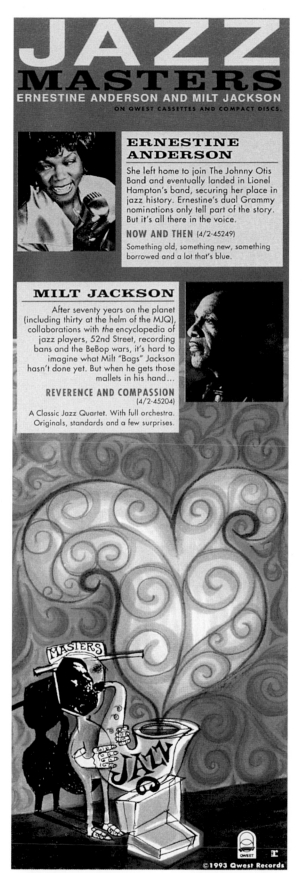

Bite of Seattle has called on Modern Dog's talents for several years. This is Raye's take on the event.

I'm a great believer in free association. When I begin to think about a design solution, I let my mind go. I unlock every mental door, through which all ideas or creative directions are allowed. As a result of this process, there seems to be a tremendous linking of one idea to another idea, which may seem like a logical, step-by-step process, but it's the complete antithesis of that. Free association takes ideas from all directions. No ideas are shut out. For me it's the essence of creativity. As a child I was a daydreamer. I was always imagining things and creating imaginary links of ideas. This childhood influence has made it very easy to fall into free association. Even if I'm talking with someone, I'm free associating—I hear virtually every word and I feel the emotion in what they are saying.

Kit Hinrichs
Pentagram Design, Inc.

"My creative process is two-step. The first step is information gathering. I'm as eclectic in the number of people I work with on a project as I am in my design feelings and interests. My own team, writers, clients, and sometimes consultants and historians, all bring something to the party. We talk about ideas and directions, then I go away and put down a range of sketches for visualizing what's going on inside my brain. Something also happens at this point through the hand-eye coordination. As I draw images, they spark other ideas. The literal process of drawing is integral in the development of ideas.

"Organizing and presenting information in a clear and compelling hierarchical order is a key part of my role as a storyteller. In researching for a typical project, I gather hundreds, if not thousands, of bits of information and images. Sharing the richness of these experiences with readers may, for example, take the form of not a single illustrator or photographer but ten, fifteen or twenty people, each of whom reinterprets the information in fresh ways. This collection makes a phenomenal storytelling tapestry of the experience."

The information gathering for the Quest paper promotion was typical of Kit Hinrichs's creative process. In an initial brainstorming session, Hinrichs met with the copywriter and the client, Simpson Paper, to discuss the product, a brand new paper using a brand new technology. The client felt strongly that this technological breakthrough would have an international effect; they also wanted to distinguish their product from other recycled papers. From this discussion the product name "Quest" emerged, quest being man's pursuit of new, vital things that change life. The discussion grew more specific as it identified the major things that man quests for: economic stability, shelter and art, among others. These ideas created the framework for the promotion. According to Hinrichs, "It was easy to pick this broad cornucopia of ideas, but we felt it was important to talk in the piece about specific quests that people were experiencing at the time; for example, the Berlin Wall had just come down and medical breakthroughs were happening. These gave concrete evidence that the quest was taking place."

America's shift from an industrial to an information economy has given urgency to restructuring public education. Even blue-collar jobs now require less muscle power and dexterity and more intellectual skills. With a vested interest in the quality of future workers, business is actively supporting schools with grants, equipment, time and expertise. Corporate efforts range from employee volunteer tutoring and mentoring programs to major donations of computer and electronic equipment. As American education enters the Information Age, business is facilitating the transition by showing educators how technology can be applied effectively to administrative functions and can assist teachers in delivering the curriculum while freeing them to give students more individual attention.

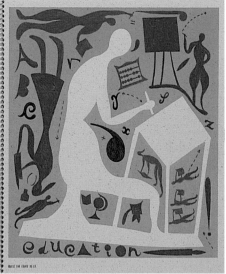

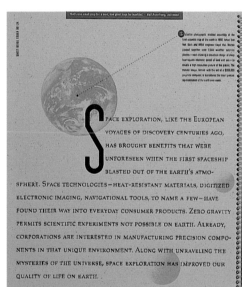

SPACE EXPLORATION, LIKE THE EUROPEAN VOYAGES OF DISCOVERY CENTURIES AGO, HAS BROUGHT BENEFITS THAT WERE UNFORESEEN WHEN THE FIRST SPACESHIP BLASTED OUT OF THE EARTH'S ATMOSPHERE. SPACE TECHNOLOGIES—HEAT-RESISTANT MATERIALS, DIGITIZED ELECTRONIC IMAGING, NAVIGATIONAL TOOLS, TO NAME A FEW—HAVE FOUND THEIR WAY INTO EVERYDAY CONSUMER PRODUCTS. ZERO GRAVITY PERMITS SCIENTIFIC EXPERIMENTS NOT POSSIBLE ON EARTH. ALREADY, CORPORATIONS ARE INTERESTED IN MANUFACTURING PRECISION COMPONENTS IN THAT UNIQUE ENVIRONMENT. ALONG WITH UNRAVELING THE MYSTERIES OF THE UNIVERSE, SPACE EXPLORATION HAS IMPROVED OUR QUALITY OF LIFE ON EARTH.

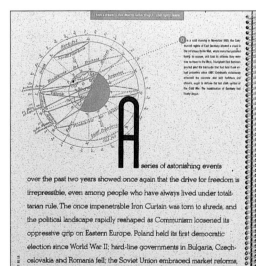

A series of astonishing events over the past two years showed once again that the drive for freedom is irrepressible, even among people who have always lived under totalitarian rule. The once impenetrable Iron Curtain was torn to shreds, and the political landscape rapidly reshaped as Communism loosened its oppressive grip on Eastern Europe. Poland held its first democratic election since World War II; hard-line governments in Bulgaria, Czechoslovakia and Romania fell; the Soviet Union embraced market reforms, and Germany was reunited. While serious problems remain, there is new hope that more open governments can address them successfully.

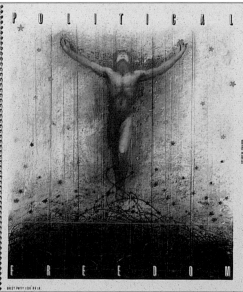

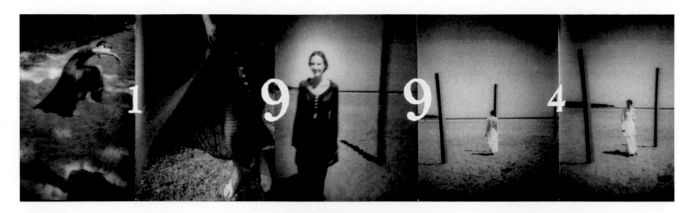

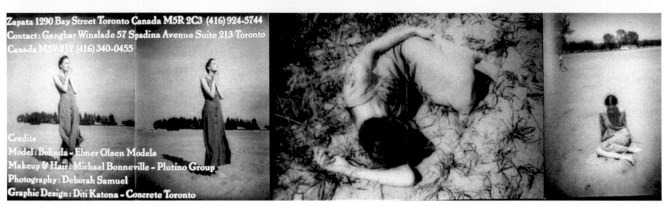

Zapata 1290 Bay Street Toronto Canada M5R 2C3 (416) 924-5744
Contact: Gangbar Winslade 57 Spadina Avenue Suite 213 Toronto
Canada M5V 2J2 (416) 340-0455

Credits
Model: Belinda - Elmer Olsen Models
Makeup & Hair: Michael Bonneville - Plutino Group
Photography: Deborah Samuel
Graphic Design: Diti Katona - Concrete Toronto

Ideas From History and Fine Art

"My fine-art background still affects my designs immensely. Everything I do or think of usually has its origin in something I remember or have studied or seen in Europe. I like to know where things come from, their origins and influences, and the whole history of art, furniture and design. We use this knowledge of history often in our work—here, the Zapata brochure photography is reminiscent of the beautiful soft edges and one-point focus of Eastern European photography.

"Most of the people who buy Zapata clothes know the clothes, so these designers have a very loyal following," explains Diti Katona. "Because of that, we can do things in their fashion brochures that are different. Zapata clothes have an old-fashioned, 1940s wartime feel to them—little cap sleeves, simple necklines, chiffon and sheer materials. The pictures were taken by Deborah Samuels with a disposable camera and one model on a single afternoon. These pictures show that it is the eye and not the equipment that makes a beautiful image.

"We design the same way a painter would compose, on one plane; we don't take bits and parts and layer them. We believe in beautiful images, such as the single, simple images in the Zapata brochure, which don't have crap all over them. Why clutter them up with type? If you start with a good image, don't ruin it."

**Diti Katona
Concrete Design
Communications, Inc.**

Interpreting a Client's Individuality

"Insurance brokers all market themselves conservatively—lots of pictures of people in suits, often with phones growing out of their ears, and bold type used to stress 'partnership.' Minet, a worldwide insurance broker headquartered in the U.K., wanted to say that they are different, nontraditional, and to stress the creativity and innovation of their employees, who are creative individualists and not pinstriped clones.

"With the client, we identified a key distinction between Minet and other brokers that would become the message: Minet is a specialist; other companies are generalists. We created seven different concepts for our original presentation in London.

"The idea for the 'Cryptographers' brochure came from an interview with our client contact who had described many of the people at the company as mavericks, which conjured a comedic mental image of insurance brokers wearing ten-gallon hats and spurs. Well, the idea of mavericks didn't work out—cowboy is also slang for an amateur or fly-by-night in the U.K. But the idea of depicting the company and its unique skills through other unique—and somewhat quirky—professions did.

"By exaggerating the qualities of these professions through illustration, we could make them more curious and memorable. Each profession was depicted by a different illustrator to stress Minet's diversity. It also gave us the opportunity to match illustrator styles to the messages on each spread."

**Frank J. Oswald
WYD Design, Inc.**

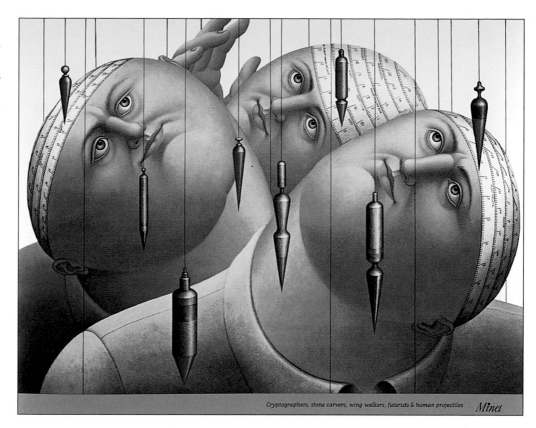

Cryptographers, stone carvers, wing walkers, futurists & human projectiles *Minet*

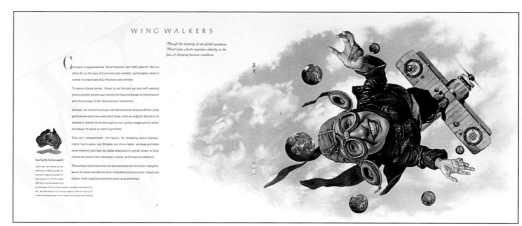

I recently had breakfast with Louise Sandhaus, a graduate student at Cal Arts who had attended a presentation I gave there. She said that my work had stayed with her long after my talk, in a way that she could not define," noted Rebeca Méndez. "She said that it communicated to her at a sensory level, one that exists outside of or escapes language. We 'know' it, but cannot explain it. For Louise, this kind of communication was best described by Roland Barthes as 'The Third Meaning.'

"Barthes's theory points to 'the existence of something which is meaning-giving but cannot be quantified.' Put simply (too simply, I'm afraid!), Barthes's theory has three levels: The first level is informational, the second is symbolic, and the third is significance that we cannot name, a communication beyond language.

Rebeca Méndez
Art Center College
of Design

"I found this reference quite flattering because I rarely hear from people who perceive or understand the more subtle levels of communication that are present in my work. There is a visceral aspect to my work that is born of my experience as a body and my thinking about the body. There is a fundamental connection between form and material, between reason and the human body.

"When I look at a piece of graphic design or a piece of art, I have always been aware of how it makes me feel, not only emotionally but physically, in addition to being aware of what I think about it. For the past four years, the body has been the central metaphor in both my graphic design and my fine art work. For example, one can treat and think of paper merely as an opaque surface and just cover it with ink. But for me paper represents skin. Surface inscriptions are like moles, hair, scars or tattoos—the origin of which may be from above or below the threshold of skin. I'm interested in what we can see underneath the skin, made possible by its translucency—veins, tendons, skeletal structure, etc. I know they are there even if I cannot completely define them visually. The three-dimensionality of what is inside of the body 'is displayed ambiguously and flattened, superimposed on one another, in a play of amorphous densities.' (Anthony Vidler, *The Architectural Uncannies*)

"Response to a piece of graphic design occurs on many levels. One is voluntary, where people choose to intellectually read the text for information and maybe analyze the symbolism of its imagery. However, there is also a level of response that occurs involuntarily.

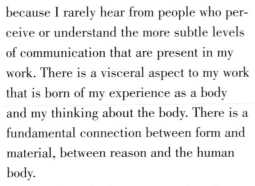

"When my friend Peter saw a small brochure I designed for Art Center, his first response was 'I want to eat this; it's a white chocolate bar!' The ultimate way to assimilate anything is by actual incorporation, so as to form an indistinguishable whole. When people wonder why they want to eat my work, I laugh. Often people's first response to my work is to impulsively rub the palm of their hand over the surface. Others have referred to a 'buttery' quality due to the way I use color and layers of ink. But I understand that they are having that visceral, involuntary response that Louise was trying to describe."

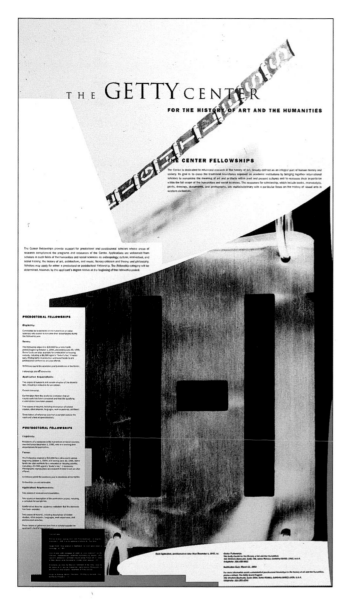

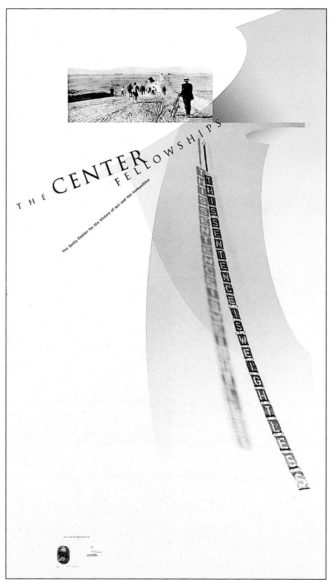

"The Getty Center for the History of Art and the Humanities is dedicated to advanced research in the history of art. Their scholars' mission as described by the Getty Center is to 'reexamine art and artifacts within past and present cultures and reassess their importance within the full scope of the humanities and social sciences.' To represent the notion of reassessment, I chose a piece from the Getty's collection by Fluxus artist George Brecht that states, 'This sentence is weightless' in negative letterforms cut from aluminum sheets. Language has no physical weight, yet the meaning of words can, of course, have profound weight. The photo of the man facing the horizon (Western Avenue and Pico Boulevard, 1903) struck me as a historical moment full of hope seeming to anticipate the future. The overall design emphasizes openness, which I believe to be an essential requisite for scholarly inquiry."

Designing With Word Lists and Free Association

Free of client constraints in the design of this AIGA poster for April Greiman's Detroit presentation, James Houff began his creative process by writing word lists and free associations.

"The phrase 'April in April,' that is, the designer April Greiman speaking in the month of April, surfaced first. What followed was the question, What does April, the month, characteristically mean. . .

. . .April showers bring May flowers.

. . .April in Michigan is particularly rainy and gray.

James A. Houff
James A. Houff Design

"Then water came to mind. I thought about what water meant as an image to express April Greiman. To me it meant highly fluorescent, electrically charged reflections on the water. So I chose saturated colors to reflect April's color palette and the influence of the West Coast on her work, which is open, fluid and colorful. The grayer, more turbulent water image represents water in Michigan.

"The flower is a symbol for May flowers and for women in design. The large letter *A* represents more than April's first-name initial. It is like an illuminated letter that functions as an icon for her and for her style of work, which she describes as 'hybrid imagery.'

"The layering of shapes is meant to produce an ambiguity of space and of the relationship of objects in space. This is a quality apparent in April's work and is an interest of mine, also.

"The bottom of the poster features a play on words with the phrase 'Will they come,' which also reads 'They will come.' In the middle of April I often wonder if the flowers will ever come. And as an AIGA member, I wondered if anything would excite the membership and get them out to attend the presentation."

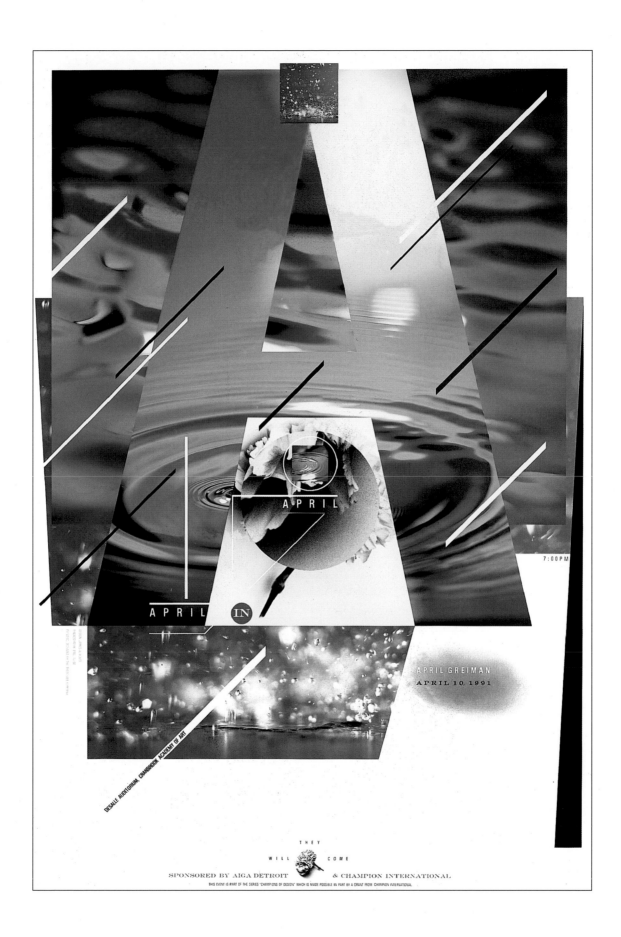

Keep It Simple

When facing a new project, Jack Summerford finds that "I don't approach the problem until I'm ready to. I may carry it around with me for a while and subconsciously chew on it, but by the time I sit down to really get serious about it, it has sort of jelled." With short deadline projects, "it's a lot of reflex. You pull out tricks that you know will work; sometimes it even ends up being better on a short notice than it otherwise would be.

"I don't have a packaged philosophy about design, but if I had to come up with a catchy one-liner, it would be 'Keep it simple.' First, have an idea; second, use that idea to communicate the message in a simple and straightforward way. Then, if you use the basic equipment of design—color, type, photography or illustration—in a direct way, it works for you."

The theme of the 1992 Greiner annual report follows up that of the 1991 book. "I told the client that in recessionary times, people get bogged down in numbers and they forget to dream, so the '91 theme became 'Remember to Dream.' In 1992, things were better. We kept the upbeat, positive note with the theme 'Things are looking up.' Everything about the '92 report is matter-of-fact, nothing esoteric about it. We shot all the photography from an upward angle—a skyward view, used good strong photographic presentation and bright, sunny yellow, sky blue PMS color accents to spice up type headings and charts."

Jack Summerford
Summerford Design, Inc.

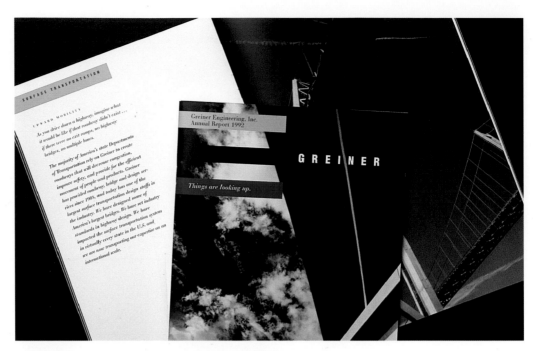

Back to the Past to Design for the Future

The inspiration for the ICOS Corporation's 1992 Annual Report resulted from a thorough understanding of this scientific client's personality and where it fit into the biotech industry. John Van Dyke stepped back and looked at that industry. "In my estimation, there seemed to be a lot of start-up companies, not unlike the computer industry. A lot of these companies were more credible than others. A lot of biotech annual reports looked flashy and gimmicky; they tried to look like high-tech medicine. The first goal for ICOS was to convey a sense of good science, which we hoped to accomplish through the use of classic medical illustration and a timeless, not faddish, design. We also felt that credibility would result from a solid and well-executed design.

"My research consisted of hanging out with the client and visiting used bookstores in order to study old medical books, to get a sense of the typography and the visuals. You can see in the annual report that the typefaces and captions are reminiscent of the feeling of medical illustration.

"The second goal was to address, through the photos and overlays, three areas of ICOS's research focus: multiple sclerosis, asthma and arthritis. The third goal, which we tried to achieve through the use of overlays and superenlarged photos, was to suggest 'humanness,' that is, ICOS does what they do to help people."

John Van Dyke
Van Dyke Company

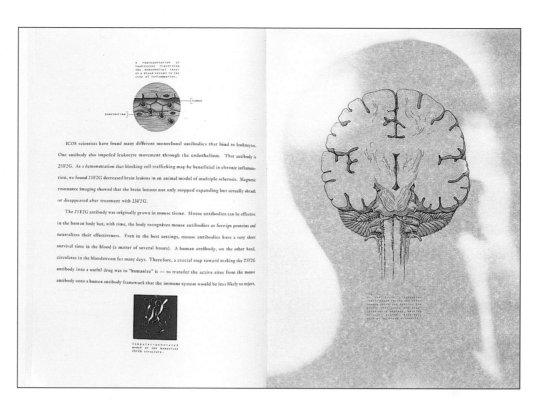

Unique Images Are the Germs of Ideas

I have a personal connection to a lot of artwork and imagery that isn't strictly graphic design, and I find unique images everywhere. My book mania is of large proportion, and many of my books come from rare bookstores and are about old typography, metaphysics, alchemy, calligraphy, medieval iconography, illuminated manuscripts, and whatever else interests me. I also spend time in the library. You'd be amazed at the kind of information you find listed under the word *lettering* in the card index. For example, if you were to study calligraphy, you'd find that the books talk about other languages

Margo Chase
Margo Chase Design

and the sources of alphabets in general. This is interesting because you see letterforms that aren't our alphabet, and a lot of the shapes are interesting. And some of them *are* the origin of symbols we do know, such as the cross and the swastika. People just aren't aware of some of the unusual sources of a lot of the design in the world.

"The source of inspiration for the Isley Brothers logo was a Dover clip art book. I saw this book in a store and bought it thinking that the monograms were amazing and that I should be able to use them somewhere. The creative director at Warner Records called about this logo project called 'Masterpiece.' The photography for it was done by a well-known photographer of English royalty and was very regal and classical. I immediately thought that the antique monograms in the Dover book were appropriate so I borrowed them.

Since there were no colors in the original line art, I chose them to fit the colors in the photo and to keep them in a regal color scheme.

"The Keith Richards logo was inspired mostly by the musician's ring, for which he is well known. Although I don't have a photograph of the ring to show as the main influence, I think it's useful to note that you can discover lesser influences too, which you will carry around in your head. For the Richards logo, a skeleton image I photographed in London's Prince Albert Museum shortly after I got the job was a secondary influence. When I got back from London and started to work on the logo, we decided to base the logo on Keith's ring, which featured a silver skull. Ultimately, the skull line art came from a clip art book of turn-of-the-century engravings of things like Victorian cartouches to which I added the grapes, banner, sword, curly bits and type to make it look more rock and roll. The line weights didn't match, so I redrew the image in rapidograph on drafting film, still retaining the old line quality.

"The logo was originally done for an in-house wine label promotion for the record company Virgin America. Virgin produced a limited edition of three hundred bottles of Keith's favorite Italian wine with this label on them. It was sent to whomever they felt they needed to schmooze. Ultimately, the logo was liked enough that it was used on the CD packaging too.

"The idea of making the CD box set packaging for Keith into something that looked like an old book or an old Bible came from seeing old books in Paris stores. I tried to emulate that look and the feeling of the way type was addressed."

Monogram from Dover clip art book.

The Isley Brothers "Masterpiece" logo.

Shot of old books that helped inspire look of limited edition CD packaging.

Skeleton image photographed in London's Prince Albert Museum, a secondary influence reinforcing the influence of Keith Richards's well-known skeleton ring.

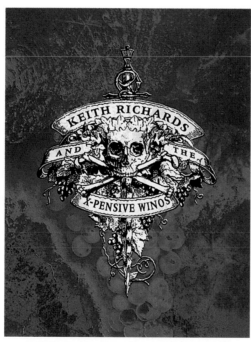

Keith Richards "Expensive Winos" logo CD packaging.

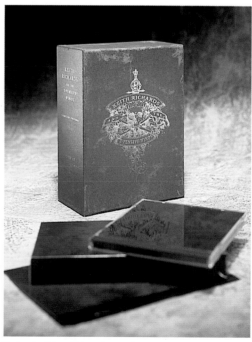

Limited edition CD packaging for "Expensive Winos."

luxus is an art form and a way of thinking that began internationally in the 1960s and continues today," explains Thirst designer Mark Rattin. "Fluxus artists question who art is made for, how it is displayed and what it is. They challenge the predetermined notions of art and of beauty. They believe that life itself can be art, so they use found objects, chance, serendipity, theory and randomness in their work.

"Because some of Thirst's concepts are fluxian in a sense, designing the Fluxus Vivus poster for the five-gallery collaborative exhibition was our opportunity to question what art and beauty are. To begin, Rick and I agreed to depart from the things that were important to us and to allow ourselves to be uncertain about the decisions we made.

"We discussed our preconceptions of beauty. What did we think this *should* be? This told us where we *didn't* want to go. We each looked around our worlds for things that charged us, which we filmed. We let our lives seep into the project. Throughout the two-week creative process, Rick and I constantly shared ideas, viewed our filmed images, discussed directions and, depending upon the music we were listening to, changed directions.

"Like the Fluxus group, the poster's design is aggressive. It is meant to set a precedent and challenge the world. It questions not only beauty but readability. Even the scale and the typography are meant to antagonize."

**Rick Valicenti (top)
& Mark Rattin (above)
Thirst**

Fluxus Vivus

4 November through 4 December 1993
month-long celebration of the work of Fluxus artists from the inception of Fluxus in the early 1960s through the present.

introduced at festivals in Wiesbaden, Dusseldorf, Wuppertal, Copenhagen, and Paris in 1962, which established Fluxus as an historical movement closely allied with the traditions of twentieth-century avant-garde art. The Arts Club's Fluxus Vivus will feature original Fluxus artists in historical and contemporary programs. Photographs by Peter Moore and posters of historical Fluxus performances will be on display in The Club's gallery; photographs of Arts Club performances will be added bit by bit throughout Fluxus Vivus.

for reservations and more information please contact The Arts Club of Chicago 109 East Ontario Chicago IL 60611 USA 312-787-3997 (t) 312-787-8664 (f)
Hours Mon-Fri 10:30-4:30 Sat 11:30-4:30 Sun closed Sun

Design: Thirst

Fluxus A La Carte Performances
Laurie Anderson Alison Knowles Larry Miller Ben Patterson and Ben Vautier
Guests at A La Carte performances will be seated Cabaret-style in The Salon. They will be offered a menu of titled performance; when selected, the piece will be performed at or near their tables.
Thursday and Friday 4 & 5 November 7 p.m. $40/20 students.
Admission includes wine, cheese, bread and fruit. Advance reservations are mandatory and are obtained by sending payment (check, money order) to The Arts Club. To secure reservations payment must be received by The Arts Club by October 28. Sorry, no cancellations.

Glass and Water, A Concert of Fluxus Works conceived and performed by Yoshi Wada and Geoffrey Hendricks Thursday 9 December Cabaret at 6 p.m. Concert at 7 p.m. $40/20 per person Reservations recommended.

Flux Concert Chicago Sky Line by Geoffrey Hendricks and Musica Inmao Tone
Friday 3 December Cabaret at 6 p.m. Concert at 7 p.m. $40/20 per person Reservations recommended.

This fall, four prominent Chicago art institutions salute the thirtieth anniversary of Fluxus—an art form that challenged the conventions of artistic media, the role of art and the artist, and the relationships between action and object, object and museum, and art and life. The participants in "Fluxus Festival Chicago 1993" include the Arts Club of Chicago, Museum of Contemporary Art; Mary and Leigh Block Gallery at Northwestern University; and Gallery 400 at The University of Illinois at Chicago.

Fluxus Festival Chicago 1993 Flux Bus Guided Tour with Alison Knowles and Bagged Lunch. Guided tour of exhibitions of The Arts Club of Chicago, Gallery 400 at University of Illinois at Chicago, Mary and Leigh Block Gallery at Northwestern University, and Museum of Contemporary Art.
Saturday 4 December Meet at 10:30 a.m. at The Arts Club of Chicago. Tour will last four hours, and will end at Museum of Contemporary Art.
$20 includes Alison Knowles' Bagged Identical Lunch, which consists of "a tunafish sandwich on whole wheat toast with lettuce and butter, a cup of soup or a glass of buttermilk." Advance reservations are mandatory and are obtained by sending payment (check, money order) to The Arts Club. To secure reservations payment must be received by November 27. Sorry, no cancellations.

Concert by Geoffrey Hendricks and Larry Miller. Four-hand Lunch Flux banquet prepared by The Arts Club's own Chef Alexander Darling.
Tuesday 16 November Cabaret at 6:00 p.m. Concert at 6:30 p.m. $40/20 students.
Advance reservations are mandatory and are obtained by sending payment (check, money order) to The Arts Club. To secure reservations payment must be received. Sorry, no cancellations.

Dick Higgins reading Intermedia Emmett Williams reading Sweethearts and other works. Thanks and More performance by Jackson Mac Low and Anne Tardos.
Saturday 20 November 1 p.m. $10 Reservations recommended.

My philosophy of 'maximum message, minimum means' was formulated early in my career and has held fast throughout it. Every message is best communicated with simplicity and a core concept that is manifested in a compelling manner and a degree of clarity that makes it easily understood. I feel that my best work has an intelligence and a substance to it.

"When I began in design in the late sixties and early seventies, there wasn't the barrage of layered information that we are grappling with today. Information has become more complex and more difficult to get a handle on, so I feel even more responsible today for finding ways to be succinct with a message, yet still find a hook that makes people pick something up and read it. My hope is to always keep the best interests of my client at heart while being as entertaining as possible at the same time.

"The *NEO: Innovations and Rediscovery* piece illustrates my thinking about design, which is less about what things look like and more about the thinking behind it. My hope is that *NEO,* and the intelligent messages that it communicates, has a timelessness to it that will be as relevant twenty years from now as it is today. It is typical of my best work, because it is rooted in classicism. Our goal was to keep the page layouts lively but still use classic, not quirky, typefaces.

"My training in architecture may be where my design temperance originates from. My work is in a way spartan, with no extraneous baggage or decoration. Only what is essential to the success of the design is incorporated. From architecture I moved into the area of fine art, specifically painting and sculpture, which today allows me to do a lot of my own illustration and put ideas down on paper in a way that communicates well to the client.

"It was during the last few years of my fine art training that I realized that to make a comfortable living I had to go into a commercial area, so I took a few graphic design courses. Right out of college I worked as an illustrator in the advertising business, and during this time my role evolved into generating concepts and marrying words and pictures. At the same time, I was building a portfolio so I could get a job with The Richards Group, which was the best studio in the Dallas market.

"I feel fortunate that my career developed in the seventies and eighties, particularly in the Southwest, where there was a mushrooming of growth and the emergence of the Southwest as a design center. My career grew with the market, which allowed me to produce a huge body of work that was published widely. I probably couldn't do that today.

"As I've spent more and more time in the design business, I've found that it can become difficult not to fall into patterns or fall back on methods that one knows will be successful. To keep my work fresh, I try to stay open to new ideas by making sure that I have the best young designers working around me. This collaboration keeps the work fresh."

Woody Pirtle
Pentagram Design, Inc.

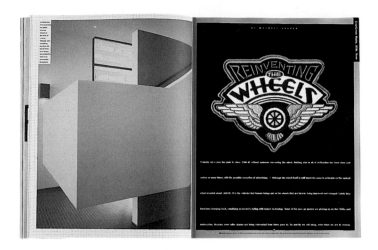

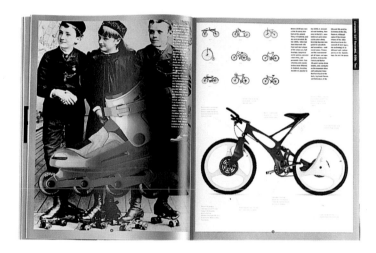

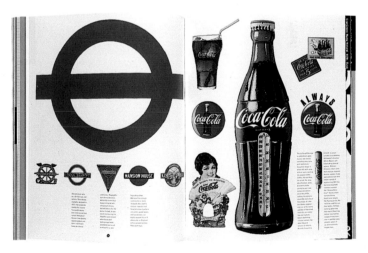

These thumbnail spreads show how Woody Pirtle's strong drawing skills communicated his ideas so successfully to clients that the visuals were approved for the final spreads.

The cover of the *Neo* paper promotion.

Working Out

Once you have a great idea, how do you give it life? There are an overwhelming number of choices to be made: Which of the hundreds of typefaces can best deliver the message? Illustration or photography? What style and technique of illustration? What photographic look? And then there's paper, ink, and so on. . .and on. . .and on. Designers in this section talk about how they brought these ideas to life and about the process of traveling from concept to comp. Some of the solutions will seem natural and inevitable; others will perhaps surprise and startle you. All were chosen to enhance, not decorate, a core message. Often the way in which they worked out their ideas was driven by not only what must be communicated and the client-imposed constraints but also by the idea's environment and the

Your Ideas

competition sending out messages in that same environment. Some of the most surprising, but ultimately appropriate, solutions arose from a desire to separate the client from the competition. These pieces are innovative because they're low tech where high tech is expected or draw heavily on the past to show a vision of the future. The projects draw on a wide variety of design techniques and mediums. They range from low tech to high tech and from simple to layered and complex in style and appearance, and cover virtually every medium of communication from an interactive computer interface to a furniture showroom. But despite the differences, all were the right approach to turning the spark of an idea into the glowing fire of the final piece.

For the catalog for Minneapolis College of Art + Design, we wanted to not just follow visual influences like MTV but to have MTV follow us. Our approach was to try to break through, instead of react to, things around and to try to create a piece that vibrates on its own visually.

"Our client, MCAD's president, made only one request for the 1993-1995 catalog: Lower the signal-to-noise ratio. What this meant was that the new catalog could be just as hot and muscular as the previous one, which we had designed, but it needed to create a little less static. So my main objective for the new catalog was to make it more legible; we wanted there to be no guessing what the text said.

"I was really careful to choose fonts for the text that I felt were highly legible. Essentially, I used Barmeno from the Mergenthaler library. The structure of the words on the page was meant to be as much architectural as it was to be language. The three-dimensional typography was, in this experiment, an attempt to bring a lot of life to the project. We wanted to maintain its legibility and at the same time bring structure and form up off the page in contrast to the hi/8 [millimeter] video photography. Since often people don't read at all, they just look at pictures, some of what we've done is make the words pictures. We did this on especially important pages, such as the 'Define' page, which describes who the client is and why.

"Other sections of the type make the speakers' voices visible. The idea of using typography as voices is something that I don't often talk about because I assume everybody does this. But because we're so much in our own world here with the kinds of projects we work on, I assume that what we do is the norm and that everybody is doing the same thing. To me, a spread is like a theater stage where you are trying to create characters and subtleties and the set design is the front and back of the page. This is why I'm interested in the three-dimensional aspects of typography where it actually becomes a voice that we haven't heard in quite that way."

P. Scott Makela
P. Scott Makela Words
+ Pictures for Business and
Culture

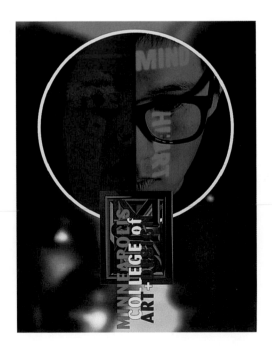

De fine

THE
Minneapolis College of Art and Design
IS A PRIVATE COLLEGE THAT FOCUSES EXCLUSIVELY ON THE
EDUCATION OF UNDERGRADUATE AND GRADUATE STUDENTS IN
VISUAL ART AND DESIGN. LOOK CLOSELY AT OUR CURRICULUM.
MEET OUR PEOPLE—STUDENTS, FACULTY, STAFF, ALUMNI. HEAR
THEIR PHILOSOPHIES ABOUT TEACHING, LEARNING AND
WORKING. TOUR OUR FACILITIES, ESPECIALLY OUR CONSTANT-
LY EXPANDING COMPUTER CENTER AND UNPARALLELED MEDIA
CENTER. ALONG THE WAY, ASK ABOUT MCAD'S CONNECTIONS—
IN MINNEAPOLIS, ST. PAUL, NEW YORK, LOS ANGELES,
FLORENCE, ITALY, OSAKA, JAPAN, AND THE PROFESSIONAL
WORLDS OF ART AND DESIGN. Ask about life, values, and
the cost of living in the American heartland, and about
the big differences between MCAD and university and
technical school programs. Find out about student apart-
ments on campus, financial aid and scholarships. IF YOUR
GOAL IS TO BE AN ORIGINAL THINKER, THEN YOU SHOULD GO TO A SCHOOL THAT HAS THE
FACULTY AND THE PROGRAMS THAT WILL HELP YOU ATTAIN THAT. IT'S IMPORTANT TO
STUDY THE EXTREMES, QUESTION CONVENTIONS. MCAD TEACHES YOU TO THINK ABOUT
WHAT YOU DO BEFORE YOU DO IT. MCAD was founded in 1886 in a modest studio above a
library. Today our campus shares a city block with a major art museum and children's theater. Our
curriculum is based on the belief that to become a professional artist or designer, one must study
theory and skill, form and content. Its Fine Arts, Design, Media Arts, Foundation Studies and
Liberal Arts programs teach students how to think conceptually, to analyze and theorize, to solve
problems and to make art. The entire curriculum is strongly enhanced by the power of the com-
puter, regarded at MCAD as a study resource akin to library books, slides, video tapes and tools.

*WE WORK WITH STUDENTS ON AN INDIVIDUAL
BASIS TO DEVELOP SELF-DISCIPLINE AS WELL AS CREATIVITY.
EVERYONE STARTS AT A DIFFERENT PLACE AND GROWS IN DIFFERENT WAYS.*
MCAD has many extras compared to other art and design programs—a curriculum that encour-
ages exploration, spacious studios, state-of-the-art equipment, a vibrant city that values the
arts. At MCAD's core are an experienced and talented faculty; motivated and curious students;
classes in which students receive much personal attention; and a rigorous liberal studies pro-
gram that prepares you for your future as a visual artist. Everything leads to the highest studio
accomplishments. The skills of the hand, eye, heart and mind are the essence of our concerns.

lets you follow your dreams.

Life

Why
do the people
WHO LIVE HERE SING THE PRAISES OF THEIR "ART-AWARE" TWIN
CITIES, THE EXTREMES OF THE FOUR SEASONS, LOONS ON 10,000
LAKES, THE BOUNDARY WATERS CANOE AREA, THE SHORES OF
LAKE SUPERIOR, MILES AND MILES OF HIKING-SKIING-BIKING-
SKATING PATHS IN 137,000 ACRES OF CITY PARKS? WHAT CAUSES
PEOPLE TO MOVE AWAY AND THEN MOVE BACK AGAIN?
The answers are as varied as temperature
changes in March:
"IN NEW YORK, PEOPLE ARE ANGRY, IN L.A. YOU HAVE TRAF-
FIC AND EARTHQUAKES. I'LL TAKE SOME COLD WEATHER OVER
THAT ANY DAY."
"THE PEOPLE ARE VERY FRIENDLY."
"THE APARTMENTS ARE GREAT."
"IT'S SAFER THAN MOST OTHER CITIES."
"WHERE ELSE CAN YOU MAKE AN ICE SCULPTURE FOR A CLASS
PROJECT OR SAIL AN ICE-BOAT ON A CITY LAKE?"
"THERE'S A STRONG UNDERGROUND CULTURE."
"THE BLUE SKY IN WINTER."
"BECAUSE WHEN YOU GO TO BERLIN OR LONDON AND SAY
YOU'RE FROM MINNEAPOLIS, PEOPLE KNOW IT FOR ITS ART
AND MUSIC."
"THE CITY HAS A GREAT SUPPORT SYSTEM FOR ARTISTS."
"EVERY STREET CORNER HAS A THEATRE. I WAS
SURPRISED BY THAT."
"I GO TO THE MINNEAPOLIS INSTITUTE OF ARTS, NEXT TO OUR
CAMPUS, AND SIT IN FRONT OF MY FAVORITE PAINTINGS."
"PEOPLE IN MINNEAPOLIS ARE VERY OPEN-MINDED."
"MINNEAPOLIS IS FILLED WITH ARTISTS WITH FRESH IDEAS.
THERE'S AN ENERGIZING FEELING OF GROWTH IN THIS CITY
AND AN OPENNESS TO NEW NAMES AND FACES IN THE LOCAL
ARTS COMMUNITY."
"THE ARCHITECTURE IS INTERESTING
AND THERE'S WATER EVERYWHERE."
"WHEN IT'S COLD, THERE'S NOTHING TO DO BUT WORK.
YOU GET A LOT DONE."
"I THINK YOU'D BE NUTS TO GO TO AN ART SCHOOL IN A CITY
WHERE THERE'S NO ART ACTIVITY. MINNEAPOLIS HAS SO
MUCH TO OFFER."
"EVERYWHERE YOU GO, THE CITY'S EYES ARE OPEN TO ART."
"I LOVE IT HERE! THE CITY IS GREAT, THERE IS A LOT OF NEAT
ARCHITECTURE AND THE RESOURCES ARE ENDLESS. YOU GOT
MUSEUMS ALL OVER THE PLACE, ALL KINDS OF MUSIC
EVENTS, AND THERE ARE LAKES EVERYWHERE FOR RECRE-
ATIONAL ACTIVITIES."

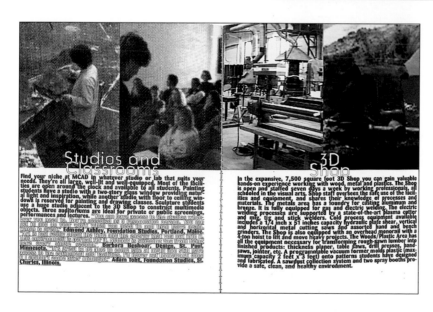

Studios and Classrooms

Find your niche at MCAD in whatever studio or lab that suits your
needs. They're all large, well-lit and well-equipped. Most of the facili-
ties are open around the clock and available to all students. Painting
students have a studio with a two-story glass window providing natu-
ral light and inspiration, while another studio with floor to ceiling win-
dows is reserved for painting and drawing classes. Sculpture students
use a huge studio adjacent to the 3D Shop to construct multimedia
objects. Three auditoriums are ideal for private or public screenings,
performances and lectures. "You can have access to the studios really
hour you need to. You're accepted as a responsible person, you can
come and go and do your work when you need to. Your work space is
what you make it." **Edmund Ashley, Foundation Studies, Portland, Maine.**
"What I find most is about the time and the classes that you put into it
and what you take out of it. The creativity is apparent from being
here." **Barbara Beshear, Design, St. Paul,
Minnesota.** "It's great to be able to come here at night and still have
access to the equipment and facilities. I'd never get the work done
if I couldn't come here midnight." **Adam Toht, Foundation Studies, St.
Charles, Illinois.**

3D Shop

In the expansive, 7,500 square foot 3D Shop you can gain valuable
hands-on experience working with wood, metal and plastics. The Shop
is open and staffed seven days a week by working professionals, all
schooled in the visual arts. Shop staff oversees the safe use of the facil-
ities and equipment, and shares their knowledge of processes and
materials. The metals area has a foundry for casting aluminum and
bronze. It is fully equipped for gas and electric welding. The electric
welding processes are supported by a state-of-the-art plasma cutter
and mig, tig and stick welders. Cold process equipment available
includes a 1/4 inch x 51 inches capacity hydraulic plate shear, vertical
and horizontal metal cutting saws and assorted hand and bench
grinders. The Shop is also equipped with an overhead monorail with a
4-ton hoist to lift and move heavy projects. The Woods/Plastic Area has
all the equipment necessary for transforming rough-sawn lumber into
finished products: thickness planer, table saws, drill presses, band
saws, jointer, etc. A programmable vacuum former molds plastic (max-
imum capacity 2 feet x 3 feet) onto patterns students have designed
and fabricated. A sawdust collection system and two spray booths pro-
vide a safe, clean, and healthy environment.

Practicing What You Preach

To promote its Esse line of recycled paper, Gilbert hired four designers, including Joel Fuller, to produce brochures for its Gilbert Designer Potpourri Series. The designers together agreed to the common theme, "What is Smart?" As a resident of Miami, Fuller is aware of environmental issues, especially those concerning the Florida Keys. To him, "what is smart" is when people think more about decisions that affect the environment.

"People don't take responsibility for the problems of the environment. In thinking about this, I realized that we *don't* see ourselves as people who can make a difference. But, we don't have to be geniuses to make a difference. The environmental solutions we showed in the brochure are simple. For example, in the Keys, hundreds of panthers are killed each year trying to cross highways. Finally, someone thought to put up a fence and build a tunnel to let the panthers go under the road to get to their habitat.

"The production of the brochure is all about being smart environmentally, too, by being aware of wastefulness. The sheet size of the paper dictated the brochure size and the number of pages.

"We wanted the piece to be more than a paper promotion. We designed it as an honest and direct piece because we wanted the companies that received it to exemplify these qualities. In fact, we sent the brochure to local government offices and agencies to show them the simple solutions that work."

Joel Fuller
Pinkhaus Design Corp.

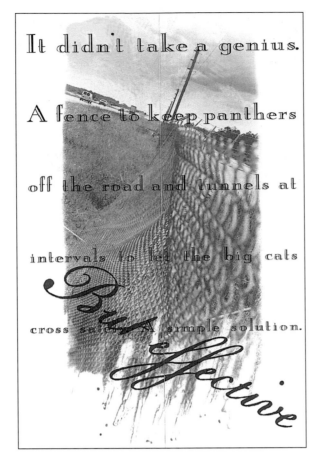

Nostalgia With a Twist

Tyler Smith begins the creative development of each new season's brochure for longtime client Louis, Boston, with a brainstorming session between designer and client. "Because of the bad economy in 1992, we agreed to do a black-and-white piece rather than something that was lavish or overproduced," Smith recalls.

As the team explored design concepts, they looked through black-and-white 1940s portrait books that depicted film stars of the era. The posed, self-aware photo styling offered a look that they felt fit well with Louis's clothing, which was in the classical tradition, and with the fashions of contemporary designers, many of whom have revitalized the golden age of '40s fashion and whose work is termed the "New American Style."

"I knew, though, that if we did a '40s look exactly, the piece would become boring because it would be too derivative. We needed to give it our own twist. So we adjusted the photo content very selectively to make it more interesting—for example, by using black models—but we always kept the '40s feeling in how the photos were shot. We also chose a small, 4½" × 6" format to make it the opposite of its historic counterpart and to make it personal and intimate."

The nostalgic theme is maintained even in the screened-back images that enliven the pages behind the text blocks. These authentic '40s images were pulled from old magazines with color added via Scitex.

Tyler Smith
Tyler Smith Design

THE NICK HILTON COLLECTION — A "NEW DEAL" FOR AMERICAN MEN

THE GOLDEN AGE OF STYLE

The 30s and 40s were a time when the world looked to America for style and direction in men's and women's fashion. Led by the Hollywood screen stars of the day, this country set a tone for stylish sophistication that has never been surpassed.

Several years ago, through the work of a special group of designers and artisans, Louis, Boston began to revitalize this golden age. Today, the "New American Style" is embraced globally from Tokyo to Milan, and you'll find no better example than the innovative work of Nick Hilton and Garrick Anderson. They, each in their own way, seem to be pushing the right buttons that will determine the direction of men's clothing in the future.

5

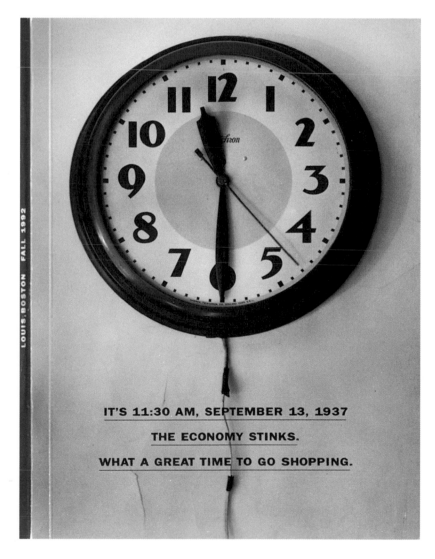

LOUIS, BOSTON FALL 1992

IT'S 11:30 AM, SEPTEMBER 13, 1937

THE ECONOMY STINKS.

WHAT A GREAT TIME TO GO SHOPPING.

Sometimes it pays to take the initiative. For Sheree Clark, partner in Sayles Design, such was the case. "A client we had worked with in another capacity for several years was now the president-elect of the Insurance Conference Planners Association (ICPA) and had the responsibility for planning and promoting the 1993 ICPA annual meeting in San Antonio. She approached Sheree about our designing the conference promotion materials. We were to begin work as soon as the ICPA board approved a conference theme. Sheree proposed that *we* go ahead and develop a theme for the board to approve, to ensure that we would have something to work with that had good visual potential. The client agreed.

John Sayles
Sayles Graphic
Design

"The theme we presented was 'San Antonio: Get a Feel for It.' It was perfect for the ICPA group: As meeting planners, they visit cities to get a feel for how the destination would work as a potential meeting site.

"Since San Antonio is a city rich with textures and different cultures, we used a variety of textured materials to carry out the design. The preconference mailer was sent to ICPA members in a burlap bag that we purchased through a local popcorn manufacturer. The brochure inside has as many textures as the city—varnished chipboard, branded leather, a silver pin and stamped sheet metal adorn the cover. The piece is bound with a suede thong and held in place with a silver concho. Inside, the pages alternate original

illustrations screen printed on a premium cover-grade stock and text pages offset printed on kraft paper.

"One of the most challenging parts of the project was getting it all to work as one unit, especially since we had more than a half-dozen vendors each doing a small part. The most difficult element to produce was the metal plate on the cover. It's made of run-of-the-mill sheet metal—the stuff ductwork is made from. I convinced our printer to make a die of the San Antonio type and then emboss the metal in their Kluge press. We were sweating it for a bit, hoping it would work with no damage to the press—and luckily it did."

In addition to the mailer, the "Get a Feel for It" campaign includes posters, on-site materials and even decorations.

No, it's not a lamp base . . .it's a lawn sprinkler! This is one of the odd artifacts John Sayles has collected.

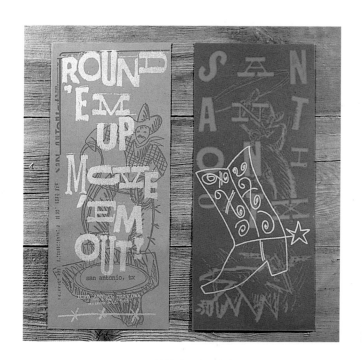

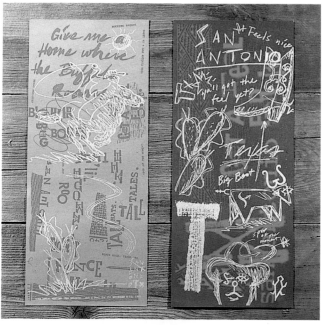

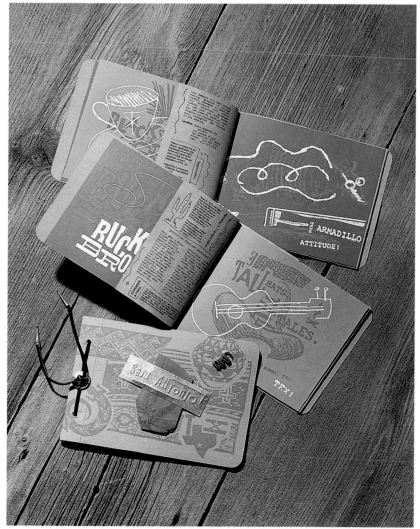

Mastering the Art of Allusion

"A lot with a little" is how Craig Frazier describes this mark for Interstar, a new independent film distribution company. "It's designed to be very iconographic. It is a simple use of geometric shapes combined with a letterform to create an illustration of the company's name. While it's very geometric, it's also dynamic. The ellipse isn't perfect, the letter *i* interrupts it, and the orange sphere acts as a bull's-eye. The three-dimensional sphere doubles as the dot on the *i* and a planet. The partial view of the *i* alludes to something within the ellipse. Everything about the mark is alluded to, shown in partial view. Showing the entire thing would have spoiled the fun of looking at it."

The elliptical mark, the designer's own preference, was chosen from the four design solutions presented because it "fit all the qualifications of a trademark, had the strongest presence when reduced, and was the most suitable to animation. The depth of the ellipse is very purposeful. The point is to give the viewer more than what you are really showing him. I wanted the mark to be engaging and to make the viewer participate. It's that participation, that investment, that hopefully makes it memorable."

Craig Frazier
Craig Frazier Design

INTERSTAR

INTERSTAR

INTERSTAR

Building an Image by Hand

"The main character, 'Milwaukee Man,' for the Design Milwaukee Call for Entries was built by hand from gathered imagery. Following a sketch, parts were pasted together in a trial-and-error fashion until we were happy. Each part had to represent architecture, industrial design or graphic design and had to reflect Wisconsin design or designers. Once satisfied, the typographic information was introduced into a Quark document along with Milwaukee Man from PhotoShop. Each panel on the poster back had a specific function and was designed accordingly. It was a real trick trying to accommodate all of the information."

Kevin Wade & Dana Lytle
Planet Design Company

design Milwaukee

Deadline for entries | 10.15 | Judges lecture | 10.23 | Exhibition opening | 11.12 | Design symposium | 11.20

Visual Communications

Industrial Design

Architecture

dMp

W

"Truly successful creativity and innovation—the type that transforms a discipline or a marketplace—is as much a social act as an individual affair. More often than not, collaboration proves to be the path of maximum advantage." Michael Schrage, author of *Shared Minds.*

Using Technology to Sell Technology

In the computer industry, where consumers buy compact discs, data cartridges and floppy disks based upon brand recognition and price, TDK had a very small part of the market. In fact, most consumers didn't even know TDK made computer products.

To change this situation, TDK launched an advertising campaign with the goal of acquiring a cutting edge position in the mind of the consumer. The Data Storage Media brochure followed on the heels of this campaign.

To illustrate the brochure, designer Bill Kochi photographed a variety of images with a digital camera. He then plugged the camera into his computer, pulled the images into PhotoShop, and combined them with photos of the products.

The front and back covers show a montage of digitized images (a flower, a nightclub singer and a circuit board), which represents the variety of images that can be stored on TDK products. The goal was to combine these images so the effect would look computerized, rather than flat like traditional photography. The mosaic effect was created using a filter.

"Using the computer to design this brochure gave me the chance to reflect what the products can do, even though you can't actually see or hear how the product functions."

**William Kochi
Kode Associates, Inc.**

Creating Visuals That Have and Add Meaning

"*Metropolis* traditionally does a thematic issue each October. In 1993, the subject was work: How do people in different fields work? Where do they think? How has technology changed the character of what they do? We were involved in planning the project from the beginning," explains designer Nancy Cohen, "because we sit in on the editorial meetings where story ideas are formulated.

"Because *Metropolis* is a visual magazine describing a visual world, it has to look as good as it reads; it has to have meaning and add meaning to a story. We illustrated the article about work using three levels of illustration. The first level shows environmental portraits that capture the feeling of the people—their state of mind—in their own environments, rather than just pictures of them. The second, technical level shows in catalog form the tools that people might find useful. Our editors researched the tools and actually recommended the best ones. The third level shows details of people interacting with their tools.

"When we assign a story to a photographer, we allow the photographer a lot more freedom since we can't pay top dollar. For the article 'The Ways We Work,' photographer Michael Ackerman took what we said, but he also improved upon our ideas and gave us something we weren't expecting."

Nancy Cohen & Carl Lehmann-Haupt
Metropolis

There were four potential problems in planning this 1,250-square-foot furniture showroom for Hickory Business Furniture: its corner location with windows on three sides allowing passersby to view the showroom from the corridor; its difficult floor plan; the limited budget for fabrication and installation; and an installation schedule of fifteen days. The challenges were to create a showroom compelling enough to draw visitors into the space and to effectively display the client's diverse line of contract furnishings and textiles.

"A highly dramatic statement was achieved by two large back-to-back 8' x 24' serpentine murals depicting two detail images by Michelangelo from the Sistine Chapel, the Libyan Sibyl and the Eritrean Sibyl. The murals were computer generated on artist's canvas using digital jet printing and were hung from the ceiling with $\frac{1}{16}$" stainless steel aircraft cables and quicklinks. The murals bisect the space and visually isolate the product. Through the classical subject matter of the mural and the dramatic way in which it was hung, the designer has created a visual metaphor for the contradiction of 'the new tradition,' the client's corporate identity. To provide a separate 'room' for the company's expanding tile line and to provide a useful storage area, two 12'-diameter white circular curtains were hung in the same manner as the murals. By use of these large-scale fabric hangings, the size of this showroom appears much larger by limiting the views and thus providing a sense of discovery at every turn.

"To highlight the newest additions to the fabric collection, large curtains were hung from display 'trapezes' at the far ends of the showroom, adding color and drama to the space. To enliven the long, linear rear wall, gold eight-point stars were applied in a grid pattern.

"A series of lightly scaled, black information stands adds a repetitive harmony to the space while serving as a source for buyer product information.

"The showroom uses inexpensive materials to maximum effect—basic black painted floor and walls, computer-cut self-adhesive vinyl stars applied to the wall, fabric curtains in lieu of building partition walls, and inexpensive steel fabricated information stands."

Michael Vanderbyl
Vanderbyl Design

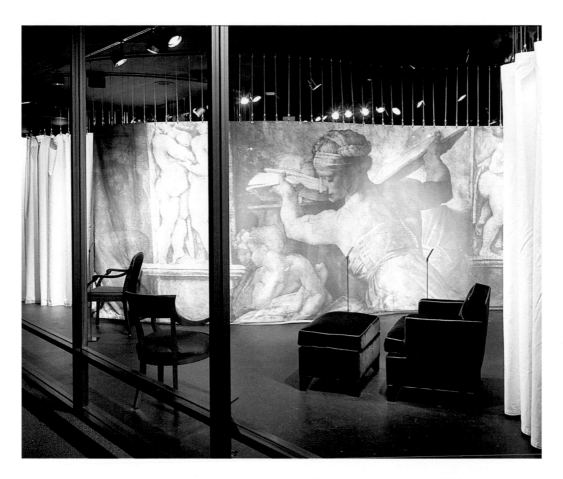

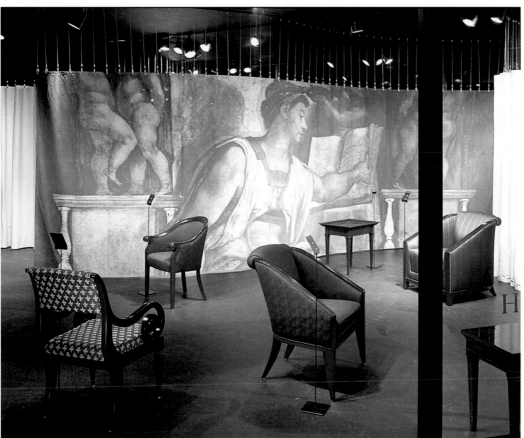

Visually Defining an Intangible

"A distinctive corporate culture has evolved at the Progressive corporation, which emphasizes, encourages and necessitates the embracing of a set of 'core values,'" explains Mark Schwartz. "These values include an exceptionally high level of openness to individual expression, vision, flexibility, risk and creativity. So for more than thirteen years Progressive has used fine art to illustrate their annual reports in an effort to challenge readers to draw conclusions about the dialogue between the fine artist's interpretation and any corporate agenda."

The 1993 annual report is the eleventh that Nesnadny & Schwartz have designed for Progressive. "In 1993, Progressive moved into the standard auto market to compete with companies such as State Farm. To tie this transition into the 1993 report we chose the loose theme of 'automobile.'"

Intrigued by the diagrammatic character of the work of fine-art photographer Zeke Berman—who would create the visuals for the book—and the concept of redefinition, the designers looked in a Merriam-Webster dictionary for the definition of the word *progressive*. This definition, printed on the back of the report, "drove everything and inspired us to create a stripped-down, dictionary-like design," notes Schwartz. The annual report's design uses tabs, exdented paragraphs, bullets, short line lengths, small amounts of copy per page and other dictionary features. Even many of the diagrams that are screened back on some pages were pulled from the dictionary.

Mark Schwartz
Nesnadny & Schwartz

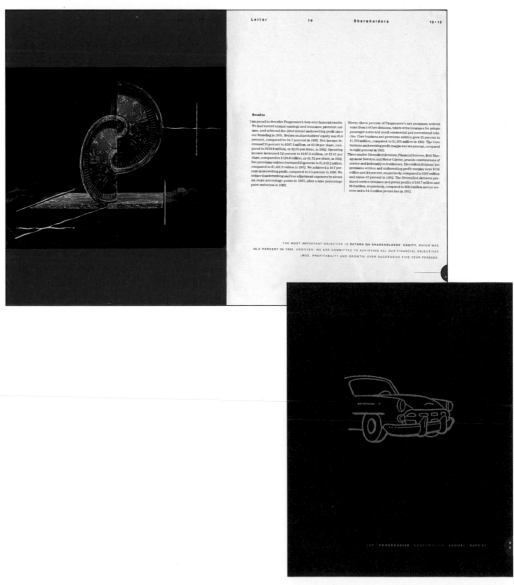

Creating High-Tech Metaphors With Traditional Illustration

"Equal is a program that lets users run popular Macintosh programs on high-powered workstations, such as IBM and Sun. As a new product, it had to look fresh and engaging, and it had to grab people's attention. The client had three requirements: The package had to say what the product does, that the company was quality oriented, and that this was a high-end product.

"We used metaphorical illustration, rather than a sterile, technical style, because we felt that metaphors were a more interesting, more human way to depict Equal's many strong features than any literal explanation. We thought that metaphors with unusual scale and angles were fun and fantastical. For example, to show the platform conversion option, we showed a figure walking along a ladder that was resting on two computers. We chose the traditional airbrush illustration of John Mattos, rather than computer-generated art, primarily because of personal taste. The irregularity of the airbrush illustration's texture added to the human element we wanted in the illustration.

"The striking color palette creates the sense of richness and quality you get from a box of fine chocolates and distinguishes the software from the standard white software packaging. The client supported this nontraditional design because it looked high-end and because he wanted to stake out a leadership position in the industry."

Earl Gee
Earl Gee Design

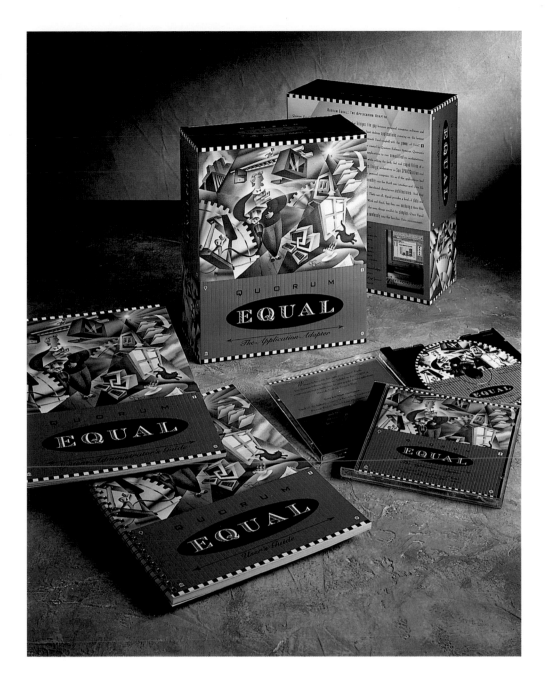

Before the hat concept was developed for this poster, which invites art students internationally to participate in the Gilbert Paper letterhead design competition, art director Alex Isley and designer Philip Bratter had played around with concepts incorporating a globe and mailing/postage. These ideas didn't work, so the team refocused on the idea of a figurative man, that is, a "letter head."

For the initial client presentation, Isley scanned Polaroids into the computer and output four black-and-white comps, each a variation on the figurative man theme. The one chosen by the client showed a man's fedora atop a letterhead. The client did ask for a different hat, in order to avoid a "masculine" look. After considering many others, Isley chose a straw hat.

The photographic props were created on a large scale: The dummy letterhead was one-and-one-half feet high and the paper clip three inches long. To guarantee that the resulting photo didn't look flat, Isley hired photographer Geoff Spear. "We needed a photographer who could instill spirit and richness through his use of light, reflection and depth. Also, Geoff has a way of adding a touch of humor. Originally, the concept was obviously a man, but it was still kind of abstract. By adding the spotlight, Geoff created a laughing mouth."

Alexander Isley
Alexander Isley Design

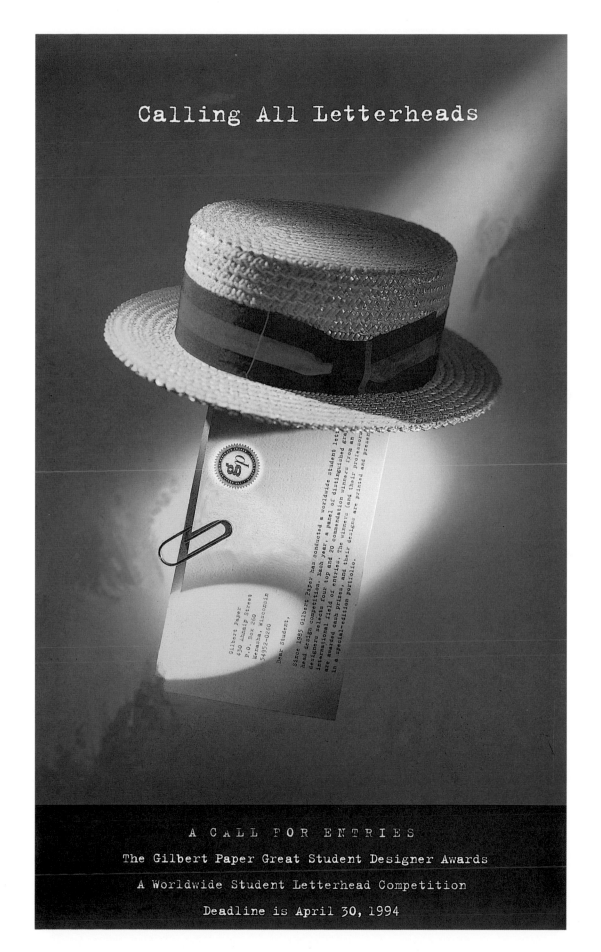

Calling All Letterheads

Gilbert Paper
430 Ahnaip Street
P.O. Box 260
Menasha, Wisconsin
54952-0260

Dear Student,

Since 1985 Gilbert Paper has conducted a worldwide student letter-
head design competition. Each year, a panel of distinguished gra-
phic designers selects four top and 20 commendation winners from an
international field of entries. The winners (and their professors)
are awarded cash prizes, and their designs are printed and presen-
in a special-edition portfolio.

A CALL FOR ENTRIES

The Gilbert Paper Great Student Designer Awards

A Worldwide Student Letterhead Competition

Deadline is April 30, 1994

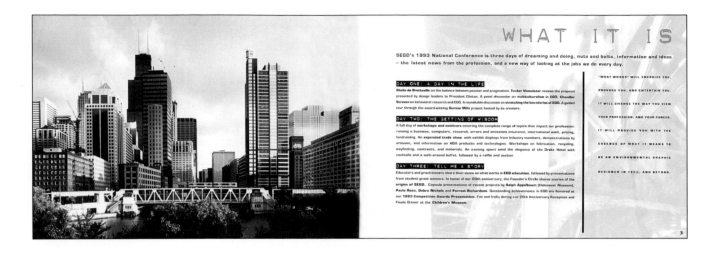

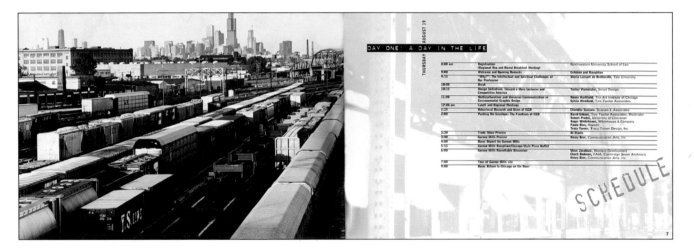

Design Supports the Concept

The client's concept, "What Works," set the creative tone for the mailer for the 1993 National Conference of the Society for Environmental Graphic Design (SEGD). "SEGD had a couple of previous conferences with low attendance and unsatisfactory content," explained Clifford Stoltze. "As far as they were concerned, those conferences hadn't worked. They wanted me to design a booklet that would communicate that this conference *would* work for the attendees, that it would be better planned and go more

smoothly than before."

To achieve these goals, Stoltze designed a functional booklet. "I wanted the design to work for the content, with the information to be better organized and more accessible than it had been." Rather than forcing the information into page layouts, Stoltze chose flexible grids that shifted as necessary to ensure that the information was accessible. The typefaces—Flight Case, Confidential, Dynamo (as in the labels) and Carton—were selected for their functionality and well-known images.

The conference's Chicago location was a major selling point, so Stoltze used photographs of the city and its environmental graphics to illustrate the booklet and to tie it into the theme, as a working city and a city that works.

Conference attendance in 1993 was double that of the previous year. Stoltze feels, "The piece was successful because it satisfied the client's needs and at the same time was visually interesting."

Clifford Stoltze
Clifford Stoltze Design

Plain Speaking

"Mohawk contacted us to create a late fall promotion for seven new lines of paper, knowing that designers needed to see and touch the papers in order to specify them but reluctant to contribute an elaborately produced piece that would just be tossed in the heap. Coincidentally, we had just culled our own store of paper promotions and were acutely aware of the voluminous waste they generated. So when Mohawk gave us the assignment, we were disinclined to use their papers as beautiful wrapping for an idea that was merely ordinary. Instead, we proposed a sensible promotion that was not just the history and social implications of the pickle fork.

"We presented Mohawk's papers honestly, rather than paint them with images and text that might obscure each paper's unique beauty. Because we assumed that when putting the papers to use designers would inevitably use their own ingenuity, we used photographic miniatures of familiar urban landscapes, 'ugly' text, and photograms of homely subjects to create a playful treatise on the power of individual perception.

"Instead of printing pyrotechnics, we simply showed each paper in use: how basic presswork responded to the special challenges presented by surface texture, basis weight, and the unique character of each side of each sheet. The unpretentious use of one-, two- and three-color offset lithography, embossing, engraving, letterpress, foil stamping and basic staple binding demonstrated the papers' practicality and beauty."

Jilly Simons
Concrete

Turning an Idea Into Reality

Faced with the challenge of depicting a building that didn't exist, Mark Geer combined a keen interpretation of the client's copy with a logical design structure to solve the problem in the South Texas College of Law's library fund-raising brochure.

The opening copy, which features quotes from such visionaries as Thomas Jefferson (from the Declaration of Independence) and John Kennedy (on the certainty of space exploration), establishes the relationship between the power of an idea and an individual's ability to make the idea happen.

"The content of the quotes differed, so I needed to find a common link, which turned out to be the concept of 'plans.'" Geer illustrated this link by juxtaposing a studio-generated blueprint drawing of Independence Hall with the Jefferson quote and one of a lunar module with the Kennedy quote. Geer pushed the concept further: Jefferson's and Kennedy's plans weren't just visions, they really happened. Partial three-dimensionality was added to the blueprint drawings to depict the evolution from concept to concrete.

The copy in the second section focuses on the college—its fund-raising effort and the planned library—and shows the project evolving through a series of tritone photos of architectural development materials—plans, thumbnails and foam core models. This progression continues the theme of plans becoming reality.

Mark Geer
Geer Design, Inc.

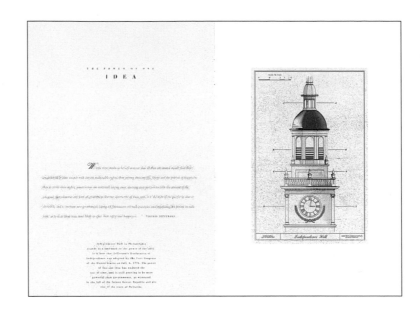

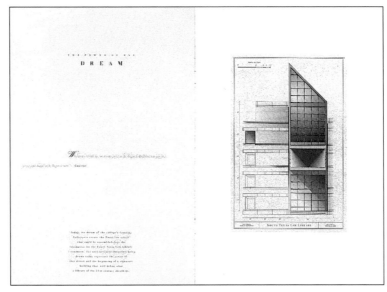

Not Just a Package But a Whole Promotion

RCA developed a radical new amorphous television design to be sold in the same price range as regular RCA models. Lou Lenzi, product manager and champion of the project, commissioned Pentagram to carry out a comprehensive graphic design program to emphasize the product's radical spirit. The designers drew on their experience with pop and youth culture to name the television and to design its logo (and choose one of several historical RCA logos to use with it), packaging, inserts and all point-of-sale materials.

For the name, Lenzi suggested the use of initials or numbers because of their ability to create a strong identity through typographic reference. Paula Scher devised the name UVU. UVU means two things: What the television is—an Unconventional Video Unit—and what you do with it—you view.

All graphic elements of the packaging, from the box's exterior to the instruction manual inside, relate to the television and the UVU logo and color scheme. Because a consumer's first encounter with a television is in a store, the boxes were designed to attract attention. No matter how the UVU boxes are stacked, they form a point-of-sale display. Only the logo and information required by law are on the outside of the box, creating an air of mystery. In addition to the television, each box includes a T-shirt, a point-of-purchase display and a poster for an instant, attention-getting display.

Paula Scher
Pentagram Design, Inc.

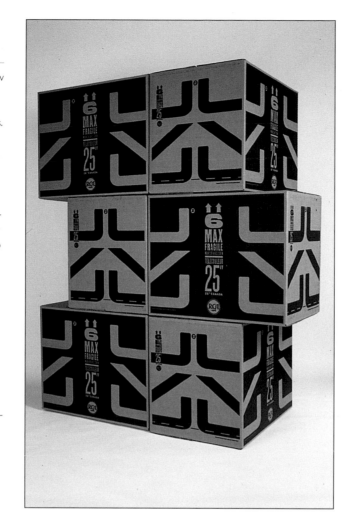

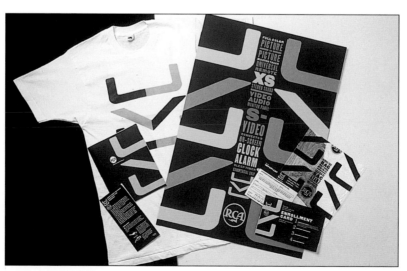

I always had a notion that film title credits were a portion of the film that was underutilized, a time when people went to the bathroom, chatted or ate popcorn," recalls Saul Bass of his early work in film title credit design. "I saw the titles as an opportunity to establish the attitude and feel of the film through the use of a reductive symbol, a universalizing metaphor, so that by the time the film began, the director had the audience in his emotional area.

"During the past two to three years, we have seen a resurgence of interest in our doing film credits, so my wife, Elaine, and I have collaborated on titles for movies including *Cape Fear* and *The Age of Innocence*. When we undertake a new film, we begin by trying to absorb everything we can about it. We read the script and the novel, if the film is based upon one, talk with the director about his point of view and his approach, see pieces of the film if they are available, and then agree with the director on an attitude.

"For *The Age of Innocence*, we saw the title as deliberately ambiguous and metaphorical. The kind of notions we had in mind involved an attempt to project the romantic aura and surface of the period and still signal its submerged sensuality and hidden codes of conduct.

"We looked for a metaphor that expressed suppressed sexuality. The concept for *The Age of Innocence* consists of a series of metaphorical layers. One layer is of lush time-lapse blossoming flowers evoking the Victorian romanticism of the

Elaine and Saul Bass
Bass/Yager & Associates

period. Each flower starts as a closed bud, and slowly and inexorably explodes to fill the screen. The continuous series of long dissolves from flower to flower creates a sensuous overlay to the notion of Victorian innocence. The first flowers blossom slowly, sedately. As the dissolves progress, the tempo of the flowers' openings moves from leisurely to very rapidly and dramatically, resolving into an intense compressed montage of flower openings. To achieve this effect, we framed the flowers very tightly and optically double- and triple-framed already highly overcranked footage to heighten the effect of slow motion. This created a very intimate look at the unique characteristics of each flower and the almost dancelike movements of the unfolding petals.

"Another layer is the superimposed lace patterns. When the flowers are closed, the lace is barely perceptible. But when the flowers are open and fill the screen, the lace textures are fully revealed and become the filter through which the flowers, and the 'Age,' are viewed.

"The third layer is the pattern of Victorian calligraphy under the first group of credits, to again augment the Victorian character of the title and to suggest the film's literary origin, that is, Edith Wharton's novel.

"As we developed this title credit, we found that we needed to have something to work against, something to give the visuals an underpinning. We laid in the overture to the opera *Faust,* which Elaine, who is a composer, recut to fit. *Faust* had a sense of threat that worked beautifully against the flower and the feeling of innocence. In fact, it worked so well it was left in as the title credit music."

When CollegeView™ approached Clement Mok to design a user interface for a new software product, they also hired two other design firms to do the same thing. The designer was told that the product was a computer-based interactive college catalog to be used by high school students for accessing information on four-year colleges around the country. The client provided each design firm with a prototype of the software but no guidelines about the look or the feel they wanted.

From Mok's viewpoint, this rather loose direction was good and bad. While it gave the designer the freedom to define the product's specifications, it also resulted in time spent speculating about what the client wanted.

The process of satisfying the client's need began with the assembling of a team, which was made up of Mok; Steve Simula, who knew how to simulate interactive behavior; and Sheri Bauer, who served as project manager.

Clement Mok
Clement Mok designs, Inc.

The next step was to review the prototype and make a complete set of screen captures—over forty of them. After laying these out on the floor, the team studied the material, while always asking themselves, "How does the viewer need to use this information?" They then remapped the entire structure of the software, consolidating and separating screens and information as needed to make it more usable. Because Mok was working with a prototype, he was free to add new features.

From there the software was mapped onto white board. Mok then built a navigation structure and grid and created a design format for each screen. This process determined things like the size of the display area and the location of buttons and titles. Details were then defined; for example, the color of buttons and whether sound would be attached to them.

Visually, Mok wanted to get away from the expected collegiate look, since this was a new medium. A conservative, proper and institutional look was out. Mok went for something contemporary, looser and with a twist.

The key graphic element that captured the desired look was the use of animated "agents" or human figures who walked and talked on the screen, guiding the user through the software. The designer actually did a casting call to look for actors who would fit collegiate roles, such as class clown and serious student. These characters were developed down to their body language, and their actions were then videotaped.

In designing software interfaces, "time is a big factor," notes Mok. "There is often not enough time. And there is no finished piece. Everything gets updated and altered as new features are added. The CollegeView™ software has been out for three months, and it's already being refined. I go into each one as if I am creating a new product. I look at it as product development, rather than designing a screen layout. This attitude has changed my approach. I use all sides of my brain.

"My background in film and video has influenced my design. Little did I realize that so much has changed, but little has changed. What I do now is a different editing process with different tools, but the goal is the same."

The initial screen that the user sees when entering the College-View™ program.

Professor Hartman, a help agent, explains the program and instructs users to select one of the four sections.

Max, a student agent, appears in front of and behind various folders and lists explaining the College Search section.

The number of colleges that match the user's prioritized criteria appear in the upper-right corner. The user can view a "tour of the campus and even modem for more information."

Improving on Client-Supplied Visuals

"Caterpillar's thirty-five-year history book was produced for employees of the company, and for this reason we wanted to feature the information graphically, like a picture book, so it would be friendly and fun to read," explains project designer Don Emery. Because of the company's relatively brief history, source material was limited in quantity, requiring the designers to draw heavily from their repertoire of design effects and techniques for the three-color, one-varnish book.

"Most of the book's images were taken from these archives, so they were not in pristine condition," recalls Mark Oldach. "We enhanced the images through techniques such as silhouetting and cropping; we turned newspaper images into line art; and we enlarged small images." Duotones were used to add a historical look, depth and color. "Color and the preembossed black cover stock were instrumental in reinforcing the book's image," explains Oldach. "Yellow and black are Caterpillar's corporate colors. The metallic silver represents metal."

Mark Oldach
Mark Oldach Design

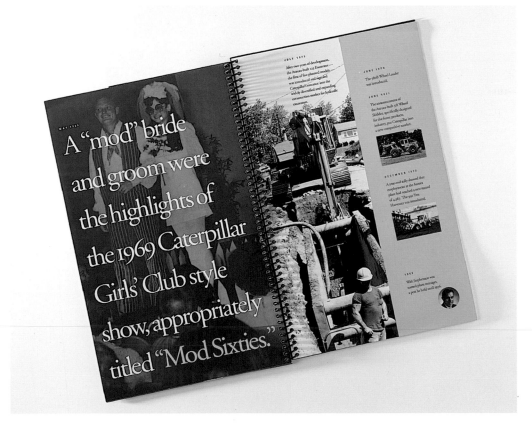

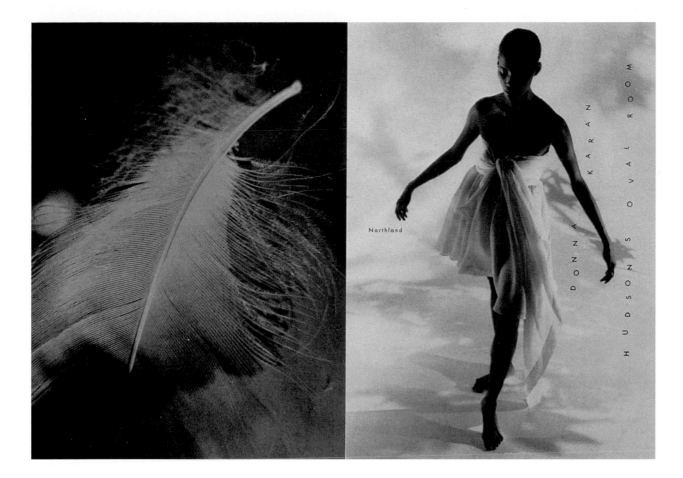

Communicating a Feeling Through Photographs

According to Bill Thorburn, one aspect of fashion is that "What happens in life, happens in clothes. Today's customer has shifted into a softer and more spiritual style. This is a comfortable age; the clothes have gotten looser. The product in this spring ad for the Oval Room reflects this age: diaphanous, airy, pure, wispy and gossamerlike."

Thorburn "spent a week with the fashion buyer in New York City just listening to her and to what she had seen in some sixty-two collections. I tried to sense where she and the designers had put their emphasis. Each designer had his own fashion vocabulary that you can tap into. And it was important to try to understand how the designers used fabric.

"When planning the shoot for the Oval Room ad, the photographer and I talked about the purity and quality of the material, its fluidity, and about Martha Graham and dance. We decided on no makeup, jewelry, shoes. We wanted to depict a woman getting out of a lake, with no ground, horizon or location.

"It was important to get the right perspective on the clothes. The model put the clothes on to get a feel for them and to understand what the designer was trying to do. We defined parameters up front because we had to keep it focused and connected to a point of view. We also have to allow for serendipity. We can sell a tone and a perspective, but in the end no one knows what the image will really look like."

Bill Thorburn
The Kuester Group

Luckily, for me at least, Mohawk's Vellum paper was a rather difficult paper to promote. Unlike many popular uncoated papers today, Vellum doesn't have a particularly interesting texture, fiber content or finish. Mohawk considers it, simply, a moderately priced everyday paper. So a lot of the 'hooks' that a designer could pick up as a message simply don't exist. Actually, I like Mohawk Vellum a lot *because* its lack of personality provides a clean, well-lighted place for doing good design.

Michael Bierut
Pentagram Design, Inc.

"In our first meeting with Laura Shore and Beth Briaddy from Mohawk, I suggested that we focus on the paper's generic character. I proposed that some simple, unpretentious things, such as a plain cup of coffee as opposed to fancy cappuccino, seemed to make a virtue of everyday experiences. They liked this idea of reverse chic, and we began to develop it.

"Before there was any design on this piece, there were words. I wrote an ad with the headline 'Can plain be perfect?' and the intro, which we proposed calling 'Mohawk Vellum: (perfectly) ordinary.' I did all of the research for the text myself, which involved looking through lots of books relating to the 'everyday' concept. Along the way I came across Andy Warhol's quote 'I like boring things' in Robert Venturi's *Complexity and Contradiction in Modern Architecture.* This quote led me to look for more quotes celebrating the everyday. Because I read a lot and remember a lot of what I read, we were able to dig out quotes from fifteen-year-old magazines and passages from books I had read in college. The process of getting permission to use these quotes took forever.

"The design and layout process was pretty simple. Designer Lisa Cerveny and I made a list of everyday things that seemed to fit the bill—yo-yos, baseball, paper clips, yellow pencils—and did fairly straightforward layouts that featured each object. We intentionally used a very blank-looking, but functional, typeface called Avenir.

"There was a particularly tricky part to the project: Mohawk wanted to show every color of Vellum, and there were a lot of them. Since this meant that the book couldn't be saddle stitched, Lisa looked around and while in an office supply store found the clasps we ended up using."

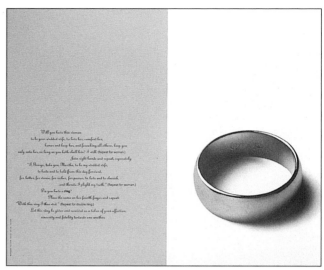

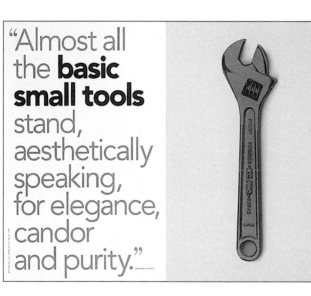

> "Almost all the **basic small tools** stand, aesthetically speaking, for elegance, candor and purity."

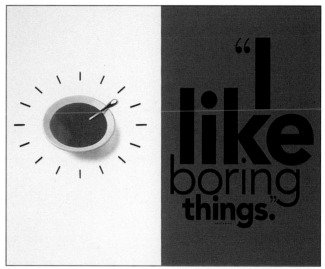

> "I like boring things."

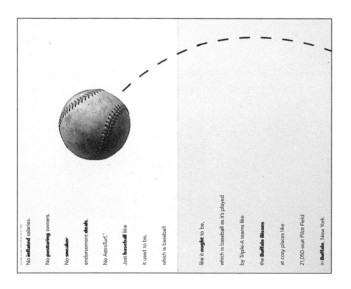

No inflated salaries.

No posturing owners.

No sneaker

endorsement deals.

No AstroTurf."

Just baseball like

it used to be,

which is baseball

like it ought to be,

which is baseball as it's played

by Triple-A teams like

the Buffalo Bisons

at cozy places like

21,050-seat Pilot Field

in Buffalo, New York.

See Spot Run.

Historic Research Nets the Right Results

Robert Louey and Regina Rubino drew upon their love of architectural history to create a building materials specifications brochure that architects would find exciting. "At the onset the project sounded unremarkable—you show stucco siding and you show a diagram," explains Robert Louey. "But we knew the brochure was going to a sophisticated audience, and we needed to come up with a concept that would increase the shelf life of the brochure and of the specification guide in the back of the brochure."

Knowing that architects study architecture for its beauty and its functionality, Louey and Rubino decided to use the first nine pages of the brochure to take the reader through a brief history of the need for shelter. "A lot of factors, such as climate and materials, are considered in the building of any home. We discovered how and why these factors affected architecture styles, facts we thought architects would find interesting. The selection of visual ideas was the most difficult part because we had only four spreads to illustrate."

Next they needed to find the right images to fit their visual shopping list, including an adobe house, a wooden post-and-lintel Japanese house and the Crystal Palace. The client's limited photographic budget was used to shoot a few black-and-white architectural shots. The other images were solicited from the collections of photographers, illustrators, stock houses and historic archives.

**Robert Louey &
Regina Rubino
Louey/Rubino
Design Group**

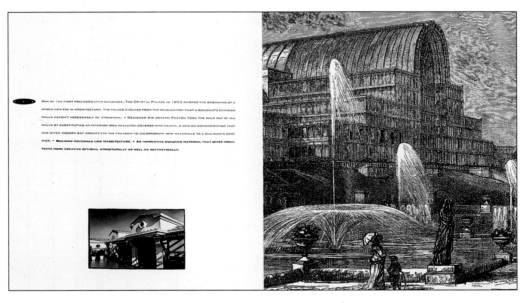

Photography Creates Appetite Appeal

When Brown & Haley approached Primo Angeli, Inc. with a packaging redesign project, their need was for a rich, premium yet distinctive look for each product and stronger, consistent branding.

The Belgian Cremes product illustrates the general design solution, which Brown & Haley accepted with minor changes in the sizing of the brand name. Designer Carlo Pagoda explains, "Photography was used to bring across the rich, creamy, dark chocolate look that the product name suggested. The previous design had used photography also, but the color was light and weak looking. It lacked strength, richness and appetite appeal."

The designers experimented with golds and grays, among other colors, for the brand name, but it was decided that the branding had to reverse out to read in most instances. Pure white reversed type was too strong, so the studio opted for a cream color.

Detailing, such as the gold drop shadow behind the brand name and the gold hairline that frames the photograph, enhances the sense of quality and richness. It is often these nuances that make the difference in the success or failure of a product.

Graphic elements used on the Belgian Cremes package are repeated on other products to create a sense of family. The brand name was positioned and sized consistently and always appeared in a rectangular panel. Different color schemes and borders give each product its own look.

Primo Angeli
Primo Angeli, Inc.

When Diana Graham was hired to create an entire marketing program for a new commercial building at 546 Fifth Avenue, she discovered that her usual approach to a real estate marketing project wouldn't work. "The difficulty with this client's building was its inherent visual obstacles: It was set off the street; the entrance was actually on Forty-sixth Street. The design of the building wasn't great—it was a cold-looking, typical glass building that wasn't much to photograph. So we had to look for a unique way to market it.

**Diana Graham
Diagram Design & Marketing Communications, Inc.**

"When a developer or brokerage firm decides to work with us, we spend a tremendous amount of time doing research. For this project, we interviewed brokers to learn what tenants were looking for in a building. We wanted to know what was important to a midtown tenant. We learned that the biggest consideration was location. Tenants wanted to get off the train and get to their offices quickly. We studied market analyses of rents in the area; we learned which tenants were looking for space and where other new properties were going up.

"Next, we met with the architect, the developer and the brokers to discuss everything we knew about the project and to agree to a positioning statement. I will not proceed from one step to the next until I get everybody to agree on a position, and

it's very difficult because everyone in this business is so busy. But I will track them down in little River City if I have to to get their signatures. Ultimately, we decided to position 546 Fifth Avenue based upon its central location: Tenants could walk from the building to public transportation, to great restaurants, large corporations and major hotels.

"We thought that it would be interesting to paint the bridgework, a fence that the builder is legally required to put up around the property, and give more character to Fifth Avenue. We found a famous Magritte painting that was perfect because it looked like English men raining down from the sky. We decided to do a spoof on Magritte because our clients were English and had a sense of humor, and we felt Magritte would be recognized by almost every sophisticated New Yorker. To introduce the bridgework, we developed teaser ads that ran on Monday, Tuesday and Wednesday. Wednesday is real estate day in the *New York Times*, so this is when we unveiled the bridgework.

"The 'high-tech' capabilities brochure provided brokers and tenants with the specs for each floor, the technical summary of the building, everything from floor plans to mechanical requirements of a boiler.

"The direct mail piece is, on one side, a map showing how few steps it took to get to the building from various points in the area; the other side was a poster, which was also used in the marketing center. This piece went out to the brokers to help launch the building and to get them interested."

Teaser ads that ran before the bridgework was revealed.

The marketing package.

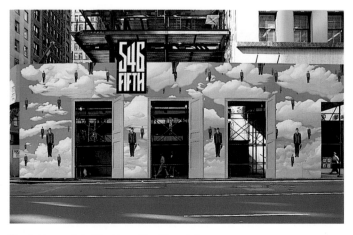

The bridgework, inspired by a Magritte painting.

Comp presented for direct mail piece.

Direct mail pieces/poster series.

Creating an Identity With an Attitude

"Scott Smith and I started the T-26 type foundry because we were frustrated with our respective design projects at Leo Burnett and at Segura, Inc. Society has placed an incredible amount of restraint on how people express themselves. In designing fonts, the feelings are different. T-26 lets these energies out.

"In founding T-26, we wanted to promote students' and professionals' philosophies of typographic design. The personality of T-26, which stands for *type* and the 26-letter alphabet, comes from the energy that we've found in our designers.

"We also wanted to explore new avenues of what constitutes legible type. We now have over one hundred fonts, and many of them, such as Osprey, feature individual letters that are collages."

The T-26 identity system has been critical to the success of the foundry, which opened in September of 1993. "Our philosophy is that typography is a treat, so we wanted a kit that felt like a treat. The burlap industrial parts bag was a vehicle for signaling a collection of hard-core, that is, very intrusive, stuff. The stuff just happens to be fonts.

"The only limitation on the objects we put in each kit is that they are reasonably priced. The logic behind some of the objects is obvious, such as the golf tee. But the napkin was included because our typefaces are so tasty they make you drool and because no one had ever included a napkin in a promo kit."

Carlos Segura
Segura, Inc.

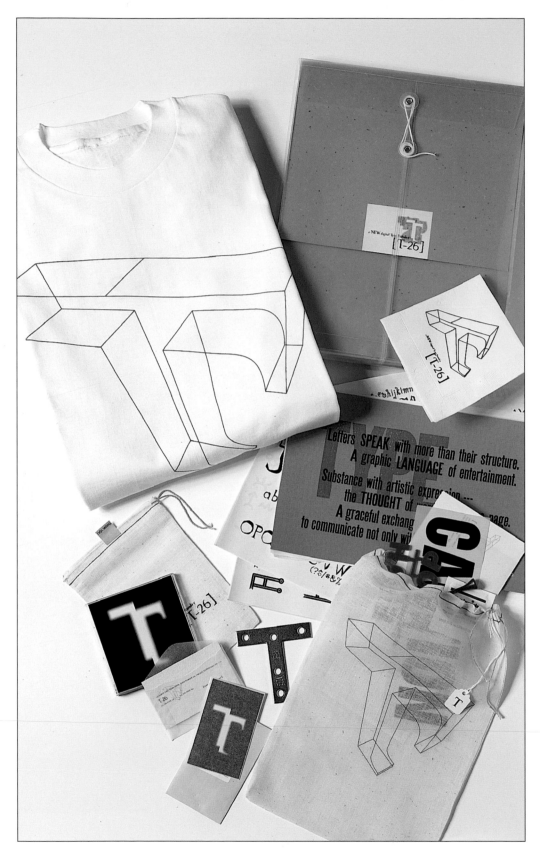

Get Input From Illustrators

"Brinkers wanted their report to stand out and to communicate their leadership style in the restaurant industry. The client wanted the report to talk about their business ten years from now *and* their business in day-to-day details. We originally thought about putting two separate books in a single folder, but that was awkward for the reader. The obvious solution was to glue them together.

"The two themes called for different illustration styles. I picked Jack Unruh for the Brinker Annual Report because he does so much detail in his work, and the report was looking at the details of Brinkers' business. The other illustrator, John Craig, does a less-detailed collage style but is able to put an involved layout and idea together well.

"When working with any illustrator I provide a layout, an idea for each page and the dimensions, and the purpose of the illustration. I give illustrators plenty of freedom to redraw the layout, and then I just leave the image pretty much up to them. In some cases, they follow my layouts pretty closely; in others they change them completely. For example, for the Brinker report I had an idea for a farmer who was scrutinizing tomatoes and not letting a bad one get through. Brinkers buys trainloads of produce for all the restaurants. But they always look at every single tomato versus looking only at the trainload of tomatoes. It was Jack's idea to give the guy six eyes."

**Brian Boyd
Richards, Brock, Miller, Mitchell**

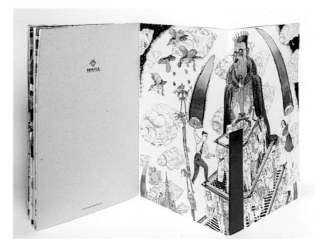

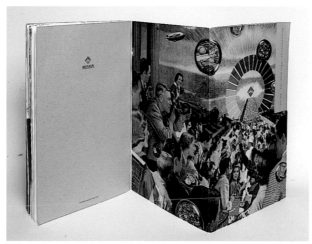

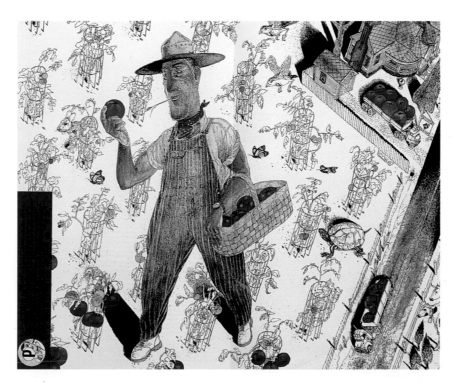

28

"I'm the only one out of the week's clippings that's going to say anything that remotely resembles reality, or reflects what everybody says but doesn't want to divulge. It's what everybody says behind everybody's back that they don't want to come out."

Gary Indiana

Gary Indiana was the first writer invited to San Francisco through Artspace's Visual Arts Criticism program. In addition to writing a feature article for the first issue of *Shift*, Indiana talked with John McCarron about his visit to San Francisco.

JOHN McCARRON.

John McCarron. We've been able to introduce you to some things here in San Francisco. Any comment?

G.I. Gary Indiana. One thing that seems to be special about San Francisco and the work of artists that interested me (this is not necessarily completely positive) is that it's a place where people can do what they want and they don't have the kind of intense scrutiny placed on everything that they do that would happen to an artist exhibiting in New York, or maybe Los Angeles. And so even though it's not an ideal situation, one thing that is ideal is that if people are really serious about their work and they want to develop it beyond the first stage of total sufficiency, they can do that. They can say, "I'm just going to go and do it," and they don't have the pressure to keep churning out the same thing over and over again for an avid market. Of course that's not ideal for an artist, either, because you would like to have a market for your work. People here can really get involved in many more creative ways. I mean, I'm a late bloomer in terms of getting somewhere with my work and I actually appreciate that now. I think that my proficiency as a writer came from having put in 15 years in total obscurity without publishing hardly anything. On the other hand, I didn't have to face that hard audience of whatever number of thousands of people look at my work now, which forces you to develop in a different way. It forces you to get really serious about

what you're doing and get really slick and really professional. I think the biggest tragedy in the arts is the phenomenon of being incredibly successful at 20 years old and burning out by 21.

J.M. Did that happen in your career development?

G.I. Well, to get serious with myself as soon as I moved to New York, I mean, at first I didn't because I had this little experimental theater group that I worked with, wrote, and so on, and it was sort of fun and games for a while. But with the facts of life and Ronald Reagan, especially in Manhattan in the 80's, I had to get serious about what I was doing. At least to figure a way to make a living with my writing. Cause it's a little different in New York to get a menial job, and also try to write. I think that that's maybe much more possible in other places. In New York, there's a lot of pressure that comes just from living in that kind of dense, urban environment. Things are much more relaxed in a city like this.

J.M. What are you going to do when you get back to New York?

G.I. Well, I have to get the novel to my agent and work a deal, and I have to start writing for the *Voice* again every week and I have to think of what I'm going to do next. I also have to edit the book of essays that is coming out next year. This is not entirely a collection of columns, but there are quite a few columns from the *Voice*. And I have to edit out all kinds of things that are sort of anchored to the weekly exhibition of... "this is here at

such and such a time." You know, all that kind of language that I don't want in my collected works. So I have to go through and weed it out.

J.M. Is it a lot of pressure writing a column?

G.I. You know, the thing is I don't always have something to say about art. The idea of always having something to say is kind of repulsive. But if you do this every week, then you have to come up with something once a week, I mean, my tactic all along has been if there's not anything really striking to write about, make up something. And usually I'm using the art that people around me are making as a jumping off point to say other things. Or let's say, what I think is maybe implicit in what they are saying. Or to make connections between works of art and the world around me. I'm not interested in handing out praise to peoples' careers. For me, it's a question of having something to negotiate through reality, which is why I want a media job to affect things around you that are good. If everything is bullshit, then you can say it's bullshit. You might be the first one to say it, and everyone will thank you because it's what they wanted to say, too. And that's a very common experience I've had working for the *Voice*. I'm the only one out of the week's clippings that's going to say anything that remotely resembles reality, or reflects what everybody says but doesn't want to divulge. It's what everybody says behind everybody's back that they don't want to come out. The Richard Serra thing is a good case in point. Most of the people that left they had to go down and testify in his favor secretly thought that this was the most ridiculous horseshit. You know, he called people up, he strong-armed them into going down and defending his piece in Federal Plaza and a lot of people declined to do this. People who have a lot more integrity really than people who buckle under went down and did it. But the sad part of that is the people that did — that felt they had to do that — thanked me for publicly saying that this was ridiculous, and that they should just remove the goddamn thing.

J.M. Your description of your book sounded like you drew from your own life experiences.

G.I. Well, I should explain something. The book is a work of fiction. I am making a character and I've given that character a lot

of the trappings of my own existence for convenience sake because I didn't want to have to invent them. It's easier for me to just take this out of my life and dump it into the book, but that's maybe one side of how I look at things for me personally, rather than that character.

J.M. Do you have any problems with things having to be removed from your column? Has it happened?

G.I. It happened a few times that the lawyer for the *Voice* has gone through and asked us to remove certain statements. Now, he's a very good libel lawyer and the fact is that the laws of libel are kind of intricate. There are ten words, for example, that you can't use to describe something. And I don't remember what they all are, but there are just certain things that you can't say. I don't think of that as censorship because if I were to put the paper in a legal situation where somebody could suffer financially, in a real crucifying way, obviously that's cutting off your nose to spite your face. I want it to be. And he protects me a little from myself because I tend to be a little excessive sometimes. I mean, it's a very strange kind of editor coaster to be on to finish one thing and then immediately think about writing another thing. And to think that you're writing for 100,000 people, many of whom would probably like to blow you away with a bazooka if they had the opportunity, and wouldn't risk a lengthy prison term. And of course the structure for writing for the paper is such that when the copy goes to on Wednesday you have approximately 24 hours to change your mind about something before it goes through copy to the printing plant. And in extreme cases anything can be pulled from the paper. But let's say that you've been unduly harsh about something or somebody and that the next morning you wake up and feel that you were a little off the mark. You might be able to change it the next day, but by Friday, forget it. There's no way you are going to

29

"I think the biggest tragedy in the arts is the phenomenon of being incredibly successful at 20 years old and burning out by 21."

An Organic Approach to Fitting Text

"A few years ago, Emigre was invited by Artspace Gallery in San Francisco to design *Shift* magazine. Intended as an independent outlet for art criticism, reviews and interviews with artists, *Shift* also featured original art projects created for the magazine by such diverse artists as Tom Marioni, Karen Finley and Gary Panther.

"In order to establish some kind of recognizability for the magazine, we chose a horizontal format. Vertical black bars along the edges of each page, with bold page numbers reversed out in white, provided a simple yet obvious identifier, tying the pages and various issues of the magazine together.

"We decided not to set up a prefixed grid since they can cause certain problems, especially when it comes to fitting in text. I started using what I ended up referring to as my 'floating grids.' I gave up entirely on the idea of all text columns being the same width and length. Too often I would be left with one or two lines that didn't fit into the allotted space. So, I started to widen certain columns and shorten others to make the text fit perfectly. In the end, I was wrapping columns around each other and creating an entirely organic approach to text fitting. But I did end up spending too much time getting the composition of these columns perfect. So the last two issues used a very simple, two-column grid that sped up the design and production processes."

Rudy VanderLans
Emigre Graphics

S h i f t The candles in the draughty church flicker, giving shadows and shapes projected onto the stone wall a life of their own. They flutter like angels, spirits, whispers, sighs: enlarged images of the cut-out objects behind the flames. The people who come in to pray, many of whom are either visiting or in the nearby hospital, confuse the art with altar and light votive candles before the secular shrine. The artist is found at times, mystified, in a back pew watching. It is a living tableau of what he strives to create in his work: art in life, life in art.

From *Shadows and Reflections* by Deborah Wise. Continued on page 6

Volume 1, Number 2
Publisher/Executive Editor: Anne Walker. **Managing Editors:** Kathy Brew, Jody Zellen. **Design and production:** Rudy VanderLans, Zuzana Licko. **Printing:** Lompa Printing. **Editorial and business offices:** 1080 Folsom Street, San Francisco CA 94103, 415/626-9130. *S h i f t* (ISSN 1060-8931) is published quarterly by Artspace. Four issue subscription is $20. Unsolicited postage and handling. Entire contents copyright 1988 by *S h i f t*. All rights reserved. No part of this publication may be reproduced without permission from the artists and *S h i f t*. *S h i f t* does not assume responsibility for unsolicited material: a stamped self-addressed envelope is necessary for the return of all material.

5

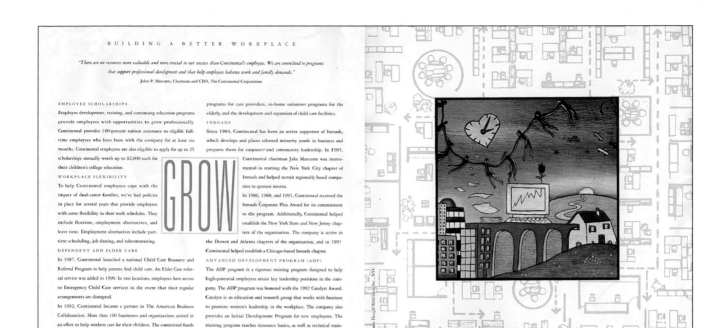

Design: Waters Design Associates, Inc., NYC

Using Illustration to Convey the Human Spirit

"After reading an early draft of the copy, we distilled four principles: sharing, providing, helping and protecting. We then looked for an illustrator whose work suggested these same spiritual feelings. Although the client had suggested using photography, our feeling was that photographs—even great ones of renovated buildings or revitalized neighborhoods—would not convey the human spirit and commitment that brought about the changes. When the client saw Vitale's work connected with key words from the copy, they agreed."

John Waters
Waters Design
Associates, Inc.

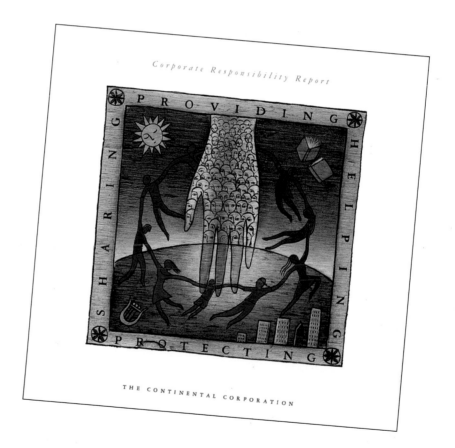

Hybrid Design Solves Unique Problem

In developing the PATH System methodology for Toronto's pedestrian network, many existing pedestrian/subway systems throughout the world were analyzed. The Toronto system was unique because of its size, its mazelike rambling, its lack of aboveground reference, and its direct connections to both subway and intercity transportation systems. When in the system, it is not possible to easily identify buildings overhead or distinguish one building complex from the next. Since no architectural standards pull the areas in the system together, people were constantly getting lost or winding up facing blank walls in dead-end tunnels.

"Our team addressed the problem of communicating wayfinding information in a creative and unique way, by developing a hybrid of the more usual wayfinding methods to address the special situation of the Toronto system. The team looked at the system not only as it exists but with its projected growth and the marketing potential to be promoted as a tourist destination and a shopping alternative that incorporates a number of sports and entertainment attractions.

"The Toronto PATH wayfinding programme that we developed depends upon the consistent application of symbol, mapping and word messages communicated throughout the system, in a family of comprehensive signs implemented consistently by all property owners. This monumental task necessitated a level of visual sophistication and appeal in keeping with the corporate nature of properties and major tenants. It had to be visually distinctive enough to be unique and to stand apart from the visual richness inherent in the retail areas of Toronto's underground.

"The schematic design of the system map forms the cornerstone for the concept. It functions as a directory, in addition to showing the expanse of the overall system and PATH links between and through buildings.

"Our analysis of the PATH System helped to define locations within the system where signage information had to be placed. These signs were designed and located keeping in mind the corporate standards and the desire of the building owners not to 'oversign.' Each property within the system was treated with the same level of importance in order to satisfy the desire of the property owners to be represented equally within the system."

**Stuart Ash
Gottschalk + Ash
International**

Close-up of a destination directional sign located through-out the system.

Close-up of a system identifier sign located at the entrances to the system.

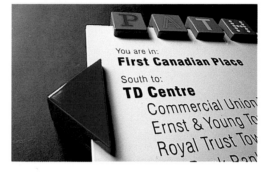

A group of ceiling-hung destination directional signs.

Concept presentation.

Ceiling-hung street sign indicating aboveground reference.

Learning From the Competition (and Ourselves)

Liska & Associates, Inc. designed a brochure for distribution to consumers and dealers that showed the advantages of their NEC monitor technology without actually talking about the technology. The reason for this indirect approach? "NEC has been a leader in the DOS PC market for years. But consumers in the Mac market didn't know that NEC monitors are also suited to their platform," explains Steve Liska.

"We saw ourselves as the average common denominator reader and end user. As Mac users, we know that Mac people want to work with suppliers who make it easy to work in applications. When we worked with the technical people at NEC, who used jargon like hertz rating, part of our job was to filter this kind of information and make the technology simple and user friendly.

"Our first step was to study Mac product materials so we knew what the market was used to seeing. We chose the writing style, typography, graphics, healthy white space, callouts, captions and silhouettes that are all part of the 'Mac look.' The result is a friendly but direct sell that Mac consumers are used to.

"The technical side of the equipment was downplayed and the satisfaction of 'needs' played up by showing applications in graphic form on the monitor screens."

Steve Liska
Liska & Associates, Inc.

The first version of the brochure.

The cover and inside spread of the latest version.

Presenting Ideas

Once you've got a great idea, how do you convince the client to go along with you, especially when the idea is unorthodox or innovative? The way to do that, according to the designers in this section, is not through a great reputation or expensive, elaborate presentations. Although it may take time (for the best-known as well as the least-known designer) to develop, a client relationship based on trust and mutual respect provides a place for creative freedom to blossom and grow. One of the keys to building a good client relationship is the ability to listen. Even clients can have good ideas. They're also likely to be experts on what you need to know more about—the product or service and the company that you're designing for. In fact, clients may sometimes hand you the solution if you lis-

to the Client

ten carefully enough. A second key is letting the client in on the process. That doesn't mean letting clients run the show. It does mean keeping them informed about what you're doing and why. It also means accepting their input, even asking for it, especially in the early stages. In other words, show the respect for your clients' insight and imagination that you want them to give you. Yet another key to developing a great client relationship is the ability to present a sound rationale related to the client's communication needs. Showing how and why an idea, especially an offbeat one, benefits clients not only persuades them of the value of your solution for a particular project but also lays the groundwork for their having more confidence in your talent and judgment in the future.

Persistence Pays Off

Imagine shooting over fourteen hundred photographs in order to illustrate a book that is only four inches square and one-quarter-inch thick. For this flip book documenting the construction of The Humana Building in Louisville, Julius Friedman, Donna Lawrence and photographer Michael Brohm positioned a 35mm, time-lapse camera armed with a motor drive atop a building adjacent to the site, and roughly four times a day, every day for one year, through all seasons and weather conditions, the camera recorded the construction. Final photo editing took a month to complete.

Ironically, this tiny gem, which Humana now distributes as corporate gifts, was originally rejected by the institution. Before publishing the flip book, "Donna was already working on a promotional slide show of the building. We approached Humana with the idea of using the book as a dedication to the completion of the building, which was designed by Michael Graves. They turned us down, having already found someone to make a coffee tin replica of the building for the same purpose. Donna and I decided to do the book on our own. After it was finished, we sent a copy to Humana, with the same offer. Selling the book was easy once they saw it."

Julius Friedman
Images

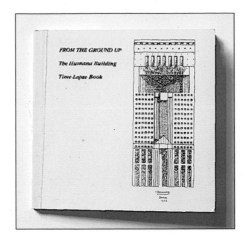

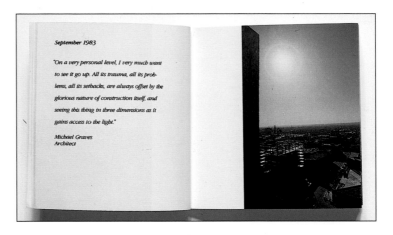

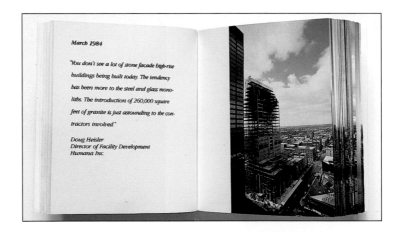

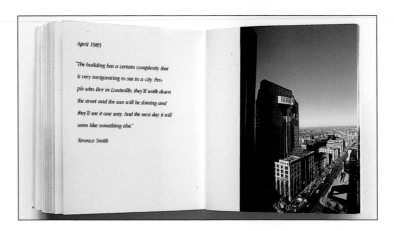

Good Ideas *and* Showmanship

"Some people have described my presentation style as a cross between a circus showman, a stand-up comedian and a business marketer. I think people have to be entertained to be interested, but all of this has to be grounded in the fact that the design and communication requirements have been thought through. Otherwise, the joke will definitely be on the designer. I make sure I am well prepared and, if I am doing a multilevel program including slides, visuals or video, that I am set, have timed and tracked it, have practiced it, and will be light on my feet—ready to react to questions from the audience.

"Usually, if the ideas are good and you've thought them through carefully, it is likely that it will be considered as the appropriate choice. That comes from getting to know your client."

Tim Girvin
Tim Girvin Design, Inc.

I seldom research a client before beginning a project. I have found that my client contact usually knows what information I need about the company to be able to grasp the assignment. I will, however, spend a good amount of time with the client. It is critical to be thorough in getting information out of a client and reflecting that information in your design solutions. The most important thing is to get input from and present ideas to the highest source.

"With Centex Corporation (the nation's largest home builder and second largest commercial builder), I meet with the vice-president in charge of communications for the company and the CEO. They review the hot topics of the past year, and together we plan a rough theme that takes these topics into account. The 1992 theme was 'the essence of Centex,' which speaks of the company's simple equation for success: People + Process = Performance.

Bryan Peterson
Peterson and Company

"Once I have input from a client and the ideas are properly incubated, I will do roughs on a layout pad. These thumbnails are sometimes shown to the client, depending on the client's level of sophistication.

More often I will tighten the roughs for presentation, still using scribbles for photo/illustration indications and lines for type indications. Most of my clients can visualize the idea from these tight roughs. If a client isn't used to visualizing an idea, we will show our ideas in the form of color computer proofs.

"For this Centex annual report, I internalized the client's input and returned with an idea that would say *construction* and not appear too feminine since 'the essence of Centex' sounded very perfume-like. I decided a magazine format would provide the best opportunity to illustrate examples of Centex's performance successes (the company continually outpaces its financial projections). Consequently, the inside text is broken into main copy, several sidebars and short stories, with the art correspondingly diverse.

"I insist on my showing the ideas to the decision maker when possible since a great idea in the hands of an unskilled presenter can appear mediocre. While presenting to the ultimate decision maker, I repeat what I thought was the assignment and ask if my description is accurate. Then I tell how I approached the assignment and how each idea provides a solution. In at least 95 percent of our approval meetings, the idea that is presented is approved because we have done our homework and not lost sight of whom we are working for."

Trust Opens the Door for New Ideas

Designers everywhere must develop a strong, positive relationship with a client to achieve a level of trust where the client can accept—and sometimes even embrace—the needed changes. Kan Tai-keung's work illustrates how trust and respect facilitate such major changes.

Careful research and thoughtful design encouraged those inside the Bank of China to modernize its image as many of its customers already had.

"The bank's current logo shows an ancient coin with the first character of the word for China in the middle. This entirely modern treatment delivers a message that is easy to understand and remember.

"This logo design was incorporated into the wrapping paper and giftpacks that the Bank of China uses to enhance its public image. Gold images of a metallic version of the logo and some lucky symbols from my own collection are scattered around the foreground of the design. The pattern printed in two percentages of silver beneath is in fact the stone carvings of a dragon, lion and tortoise, which I photographed in the Old Palace in Beijing. Both the visual effect and the color theme suit the company's solemn image as well as the grand appearance of its building.

"The Bank of China has a long history. It is not easy to convince those bank decision makers who have been with the company for many years to accept anything new and modern. So I feel especially proud that they adopted my design at the very first presentation. The research that we did contributed much to our developing a unique and suitable design.

"Changing the image of Two Girls Brand cosmetics was almost more of a challenge than persuading top bank management to accept a new look. Could the trademark be updated without losing the value of the long-standing trademark?

"Established in 1910, Two Girls Brand had enjoyed a good reputation in Hong Kong, China and Southeast Asia. By the late 1980s, though, only two or three products in the line still had the market share. Its owner, whose business was mainly in property, decided to push the brand into a younger, bigger market; develop a new and unique image; change the packaging; add new products; and shift the brand into new shops. When I took the job, I felt the strain and the challenge. The old image, of two Chinese women in their cheung-sam, was deeply entrenched in consumers' minds. Nobody thought that I could enliven it with a new image.

"My job was to create a new trademark and image to fit the new product line. I decided to create an image of a modern, confident and independent woman, yet with a sense of classicism and fashion. The profiles of two young, modern women appear on the trademark. The pastel colors and the round caps impose feelings of softness, purity and comfort—qualities that every skin care product wants to possess. The revival has proved successful. Not only did the old products regain their glamour, the new products entered smoothly into the competitive skin care market."

Kan Tai-keung
Kan Tai-keung Design &
Associates, Ltd.

Bank of China logo, wrapping paper and giftpacks.

Two Girls Brand cosmetics packaging.

Setting Ground Rules Creates Good Client Relationships

"We talk with our clients a lot about what we are doing, and we let them in on the thought process so the design makes sense when they finally see it. We also try to set up the project in advance with a proposal that explains our working process. We usually present two different directions in full-size color comprehensive form. This is done using the client's input and only after explaining what directions we are going to explore. This is phase one.

"The client understands that this is the most design-intensive phase and agrees to pay a figure to cover the time and expenses spent on this phase, whether or not they agree with, or like, the outcome. They do not own the design at the completion of this phase. They have just paid for the design time, not the design. If they select one of the designs, we finalize it and discuss usage, etc. If they don't choose one, we can return to phase one and try again, for an additional fee, or make reasonable changes to one of the designs.

"We present designs in mostly final or near-final form. A design needs to be pretty finished to know whether it works visually or not. The idea can be great, but unless it works visually, it doesn't work at all."

**Charles S. Anderson
Charles S. Anderson
Design Co.**

Fit the Presentation to the Project

"For us, client presentations fall along a broad spectrum. At one end of the scale is discussion—we just talk about ideas and walk the client through solutions in a narrative format, showing him very little. Sometimes it's just a huge blueprint that we've created to show an outline or how a family of packages or designs can live and develop. In the middle of the spectrum are looser comps, color computer outputs, etc. At the far end are the elaborate prototypes.

"For sign projects, for instance, we may build a real-life sign to actual size. We find that clients like seeing things built to scale so they can hold and touch them. Most of the time we articulate ideas by creating prototypes. We don't do flat comps very often because we don't see the value of showing something in a form that isn't real. It only opens up questions that are usually counterproductive and won't make the design better. We also present a lot of writing with our work. This is because we feel writing is often more important than the design or the color or the type. Often, the writing *is* the idea."

Forrest Richardson
Richardson or Richardson

Because our design work exists within a context, we try to understand that context very well before we begin a project," explains Senior Vice-President Terry Stone. "Initially, we audit and analyze our client's existing corporate identity and then review the competition's. Often we find that the competition is not exactly what our clients think it is. For example, our client Hughes Supply was competing not only with other building supply companies but with other Florida companies and even other national companies with a completely different type of business as possible investment opportunities.

"When we research information, we look for what our client is saying and not saying about themselves already. We determine what the competition is saying through their graphic communications. We try to analyze how our client's target audience is perceiving them, positively and negatively. Our research helps us understand just what the problem is that we are trying to solve, not just what our client thinks it is. We want to grasp that for ourselves. Otherwise, we are in danger of designing just to please a particular aesthetic sensibility, be it ours or the client's, and not really effectively communicating the message.

"After the research and analysis stages, we define a set of design criteria.

Alan Urban
Urban Taylor + Associates

Sometimes this takes months and formal documents are created; sometimes it takes hours and no documentation is generated. However, we always go through the process to clearly focus on what needs to be done.

"The next stage is exploration of visual and verbal concepts. More and more we do the writing and designing ourselves, rather than waiting for client- or freelance-written copy to drive our thinking. Typically, we explore many more concepts graphically than we are paid to do. We believe in going beyond the expected and the ordinary to the truly inspired solution. Because all staff members have Macintosh workstations that are networked into a color laser printer, we generate a lot of ideas on paper. Then we have staff-attended collaborative critique sessions to review the work produced.

"From the critique meetings, we narrow the choices to one or two to present to the client. The number of concepts presented is determined by our contractual agreement with the client. For the Hughes Annual Report, several cover solutions were offered, from mild to wild. Hughes chose the concept with the most flair, the 'wild' one. We then laid out several typical spreads for the client to review in approving the overall design.

"The report features the three basic geometric shapes: the circle, square and triangle, recurring from page to page in different placements and size ratios. They are all held within a thin blue rule line that is the only constant throughout the report. The report has a clever animated feeling because of the variety in the geometric shapes."

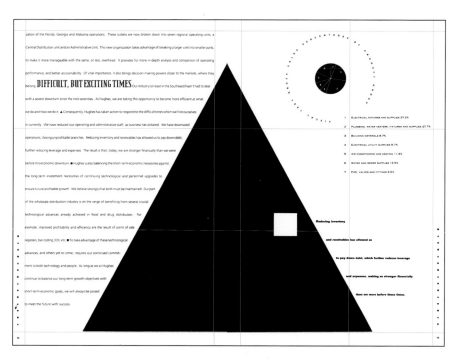

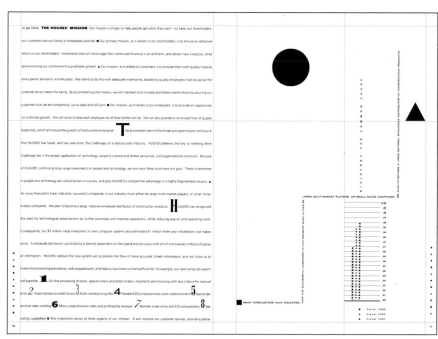

Openness to New Ideas

How do you make X-ray systems, cutting instruments, film mounts and other support equipment for the dental and medical markets interesting in the annual report year after year? Greg and Pat Samata pull off that trick for Gendex with intriguing ideas and innovative execution.

Each annual report focuses on one clear idea from cover to cover. Then that idea is expressed visually through the photography and unusual printing techniques. The 1991 book turns an old process, X-rays, into an exciting (but not expensive) new approach to photographs. In 1992, embossed images—that also appear as debossed images—alternate with duotones. For Gendex's tenth anniversary report, photographs are covered with metallic inks, and every page, including each cover, is diecut with an X, the Roman numeral *10*.

Of course, once you've come up with an innovative approach or a new idea, you've still got to persuade the client to accept it. "We have a wonderful professional relationship with the decision makers at Gendex. The Gendex management has been, and remains, open to new ideas that position them at the forefront of their industry. They share their ideas and expertise with us, so we can digest that information and create a design solution that works for them. Our relationship with Gendex has been built on openness and mutual trust, and we rely on each other's opinions. We often take their ideas, run with them and bring them to life."

**Greg & Pat Samata
Samata Associates**

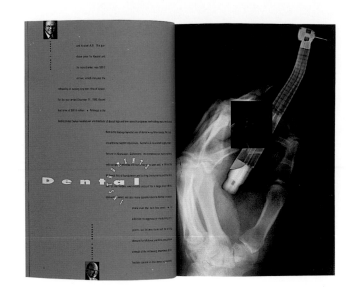

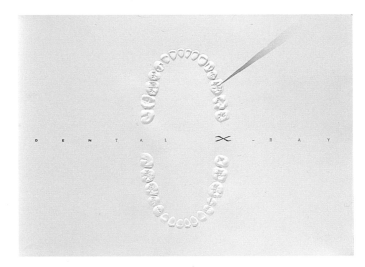

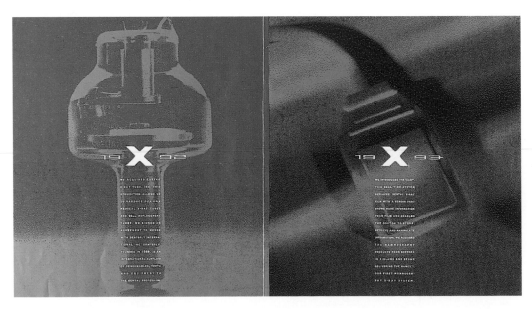

Overcoming Client and Design Constraints

Today, Jennifer Morla knows, "Designers not only work on print projects, we also create environments, design furniture, animate videos and pattern fabrics—all forms of expression and problem solving not limited to the traditional two-dimensional definition." Swatch hired Morla to create designs for the faces and bands of their basic-model watches because of her reputation as a multidiscipline designer.

The size of the product presented an obvious space restriction. But more restricting was that the designer was told she could create only line art, for which the client would eventually choose the flat colors for reproduction. "While it was a fun project to work on, I wish we could have had more design flexibility and could have investigated different types of Swatches. The constraints were more than you might think, such as the requirement of patterning on the surface of the band and the exclusive use of flat art."

Morla illustrated the watch faces with a diverse array of images, including a steaming cup of coffee; a surreal red and purple spotted chair; and a play on words where the letters R, U, S and H replace the numbers 12, 3, 6 and 9. "The Swatch project was a wonderful opportunity to illustrate with a whimsical style that was very direct and graphic." Of the twenty designs Morla created, the coffee cup and the chair designs were chosen for production and are the best-selling designs in the basic-model collection.

Jennifer Morla
Morla Design, Inc.

A Winning Presentation

Imagine competing with *fourteen* other firms for a single design project. This is exactly what happened to Lori Siebert, who ultimately got the project to create the product packaging and marketing brochures for SDRC's I-DEAS software.

"This product launch was very important, and SDRC felt that just looking at a portfolio wouldn't tell them as much as actually seeing how a designer thinks and solves problems. So an SDRC marketing team interviewed fourteen firms, from which they hired three firms to present full design solutions. We, and the two other firms, met together with the marketing and the packaging teams, which gave us information about the company, their objectives, the market and so on. All three firms' presentations had to be done following the same specific guidelines about board size, margins and color, and about design application. This way SDRC could judge the presentations on our ideas only. The creative directives were that the brochures had to look evolutionary and world class while the packaging needed to look upbeat, friendly, inviting and easy to use. The marketing team took the three presentations, which were color-coded for anonymity, and presented them to higher-ups in the company. Anonymity was required so that prior

**Lori Siebert
Siebert Design Assoc.**

alliances didn't get in the way of the final selection."

Siebert feels that her firm was ultimately chosen from the group of three because of their analytical approach to the layout structure and the look of the brochures. Careful consideration had been given to both visual and verbal elements, with emphasis on ease of use. Although SDRC liked this thinking, they actually didn't like Siebert's original design solution. Siebert continued to work with the marketing team; art director and project coordinator, Karen Kramer; the packaging team and upper-level executives to make extensive changes.

"The most difficult part of this situation was that there were no guarantees. This is difficult when you put your heart and soul into a project, and you start to think about future applications."

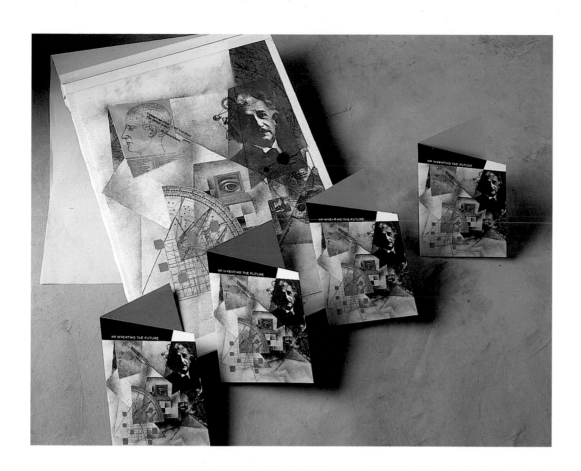

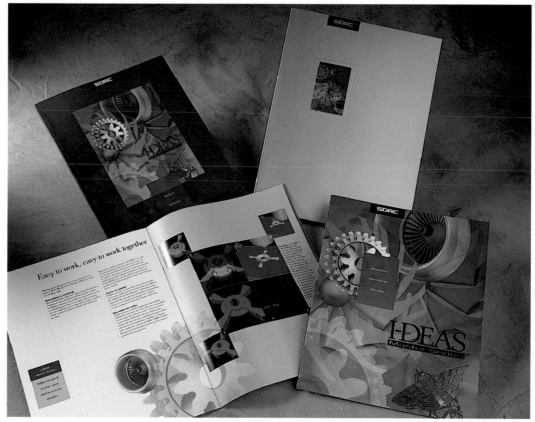

Working With the Client Toward the Right Solution

If the chemistry is right between the client and the designer, the solution can be very rewarding for those involved. 'Body Chemistry' is an example of a truly client-inspired design. Diane Richardson, one of the owners of this retail store, had produced a line of natural body care products and worked with employee Cerstin Chatham to develop a concept for the logo. She then called us to design the logo and packaging for the line.

"Usually when a client has an idea for a logo, I request that we have the opportunity to solve the problem on our own without viewing the client's idea first. Then I say that we can each bring our designs to the table and discuss the appropriate direction. But this time, the rough idea was laid on the table during the initial meeting, and I liked the concept the moment I saw it. I also knew that Diane had an investment of time as well as emotion in it.

"I worked on a few variations and gave local illustrator Susan Jaekel the assignment to render the actual body form. Susan also did an initial sketch for the typographic approach, which stylistically complemented her illustration. I designed the final letterforms and put the logo together.

"I have discovered that it isn't difficult to get clients to accept ideas if they have been made part of the problem-solving process from the beginning. By the time the presentation is made, our clients

usually have already 'bought off' on the concept. Designers don't own the market on good ideas. Whether the idea comes from us, from the client, from our high school art student intern, or from our office manager is not important. What is important is the right solution is arrived at. I'm not saying we are always right, but I am saying that our clients always seem to go with the solution that we, together, have arrived at."

Rick Tharp
THARP DID IT

The client's rough sketch.

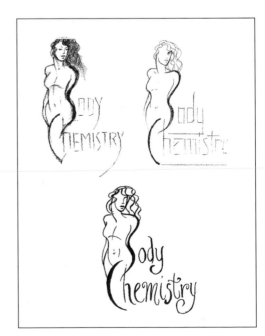

Susan Jaekel's illustrations with sketches of typographic approaches.

Jaekel's final illustration.

Rick Tharp's rough.

Jaekel's final illustration with Tharp's final lettering.

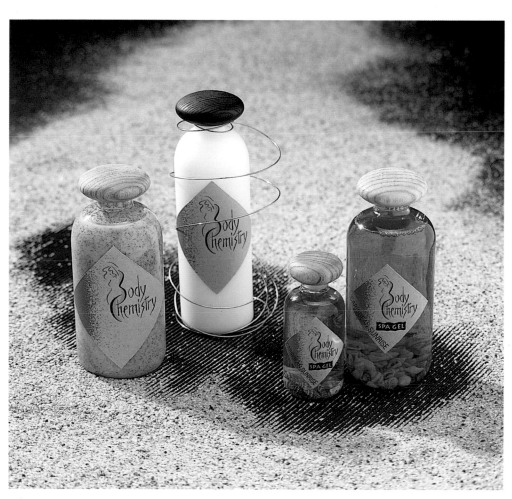

The final products.

Selling a Provocative Solution to the Client

I've never tried to establish a style, and I think it's because of the place I work and the fact that my clients need a variety of looks. I let my style evolve from the nature of the problem. The character of my work is simple and direct. I strip away the superfluous things that don't contribute to the main idea.

"I am intrigued with various aspects of design, especially from the past. I like the Art Deco movement a lot and have lifted things from the turn of the century, 1890s style. I appreciate Japanese design and its Zen-like quality."

The graphic look and the warm colors of the library poster series were inspired by antique stamps, although the designer doesn't think that this influence is evident in the posters.

The posters' design evolved from an interesting designer-client interaction. The library director came to the designer with the problem of students socializing, rather than studying, in the library. He wanted a single poster that would remind students to be quiet. He also brought along his own layout and copy. Essentially he needed the designer to pick the type and colors.

Magleby saw the potential in the project and suggested that he take the client's idea and "jazz it up." The decision to take the project beyond the client's original concept was a pivotal point because it added the challenge of developing a provocative solution and then selling it to the client.

McRay Magleby
Brigham Young University

Working with BYU copywriter Norm Darais, the designer began by poring over a thesaurus looking for different ways to tell people to "shut up." They chose "Shut Your Trap."

In the client presentation meeting, the designer first presented a "Logic List," which is prepared for every design project. The list included many reasons for the design solution including these two: The viewing distance is up to ten feet and so a dominant image was needed to attract attention within the cluttered environment. An element of surprise would create something unexpected, and so make the poster more memorable.

He then showed a tight color comp that included the "Shut Your Trap" headline. The client's response was negative: He thought the statement could be offensive. A student in attendance at the meeting, though, liked the idea, which convinced the client to go with it.

The client decided to do a series of four posters along the same line as the original. Magleby then went in search of three more statements whose last words had four letters and would fit into the layout. He came up with "Not a Peep," "Pipe Down" and "Button Your Lips." Literal visuals were used for each poster, although the original image for "Pipe Down"—an upside down pipe—was killed because the university is very strict about smoking.

Before choosing the poster colors, the designer visited the library spaces where the posters would hang. He wanted the poster colors to relate to these spaces, which were quite dark and dingy, but still stand out. He chose colors that were brighter and were warm and nostalgic (reminiscent of the antique stamps).

PLEASE

D·O·W·N

MAKE THE LIBRARY YOUR
SILENT PARTNER FOR
ACADEMIC EXCELLENCE

PLEASE

SHUT·YOUR

T·R·A·P

MAKE THE LIBRARY YOUR
SILENT PARTNER FOR
ACADEMIC EXCELLENCE

NOT A

P·E·E·P

PLEASE

BUTTON
Your

L·I·P·S

MAKE THE LIBRARY YOUR
SILENT PARTNER FOR
ACADEMIC EXCELLENCE

Building on Client Input

Ron Sullivan
SullivanPerkins

Establishing a client-designer relationship with first-time entrepreneurs can offer a unique experience for even the most experienced designer. In the case of a Dallas housewife turned product developer, her enthusiasm for Ron Sullivan's design solutions almost got in the way—she liked the designs so much she couldn't make up her mind which one she liked.

"The client's two new gourmet food products were called 'Hogwash' and 'Beefish,' and her company name was 'Ham I Am.' Hers is a Mary Kay kind of story in that she created and ran this company out of her house. After she asked us to design the product labels, we spent about two weeks working up pencil roughs, reviewing designs and refining each direction. For this client, we wanted to arrive at a design that was as unusual as the product names, while being true to the product's positioning, which was the gourmet market. Based upon the pencil layouts, she narrowed the direction further. We spent another week comping six label directions. We could have just done flat labels in pencil, but we all got excited by the concepts, so we did handmade comps on the photocopier.

"The six comps were just super. Our client could have picked any one, and I would have been delighted. She had a hard time choosing, so she took them to show

her neighbors, I guess, and some people she knew in the grocery business. They couldn't decide either. About a week later, she reluctantly chose one. We went directly to finished art, and once the copy particulars were worked out, we sent the label to the printer."

While she was contemplating the design solutions, "She went to the market and brought several jars in to us that she liked. One of them was a six-sided jar. I had seen the jar before but not very often. It was a little more expensive, but she wanted to use that jar because she thought it made the difference. She liked its image and uniqueness. I really appreciated her attitude. And, we agreed with her. Also, it was an off-the-shelf item, which made it more affordable than a custom design.

"A year later, due to customer demand, the client asked us to design a two-pack box. Budget restrictions and the preexisting design established a more limited working parameter. Because of this, only one designer worked on the box, unlike the team approach we used for the original packaging. When we presented the variations on the box design, the client was equally excited.

"We worked with this client as we do all of them, that is, with simple straightforward honesty. We let her know that we take a studio approach to every problem and that we believe in presenting multiple directions. Our directions are arrived at from a single source of information and are refined with guidance from an experienced design-concept team of creative directors. Also, we work hard to maintain harmony with our client."

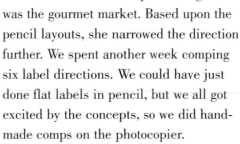

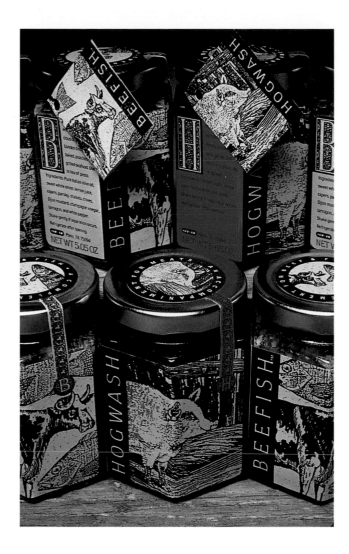

Create a Client-Designer Partnership

All projects at our studio are collaborated on as a team," explains Jack Anderson. "All members of the project's specific team meet to discuss the design criteria and any initial design directions we feel we should explore. From that point, each designer develops very rough sketches, just enough to communicate the basic idea. The design criteria, which are developed with the client, are our guidelines in creating a successful design project. Each concept in the design process is evaluated in terms of its ability to answer these criteria. This enables us to remove some of the subjectivity and allows everyone on the team, including the client, to evaluate the concepts more objectively.

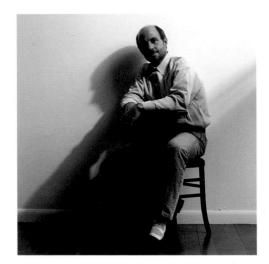

Jack Anderson
Hornall Anderson
Design Works

"After a quick first round of roughs, we all meet together to discuss the various directions and talk about which ideas are beginning to work graphically and are addressing the client's objectives. Once this brainstorming session is done, each designer works a bit more on the ideas that do work graphically and on new ideas that surfaced from the second meeting.

"We consult a variety of materials when working on a project. These materials range from industry publications detailing successful projects and why they work to art and marketing books. We also use client industry-related materials to obtain a sense of the specific marketplace in which the client operates, articles on the client and the competition, and various illustrations, photographs and materials samples.

"The next step—still very early in the process—involves bringing the client in to get early feedback, to avoid exploring an avenue that may not make sense to them, and to integrate their thoughts and ideas firsthand into the rough concept development. We keep our clients closely involved throughout the design process. They are shown a wide range of very rough drawings in the beginning, so rough that first-time clients may be a bit nervous that the designs aren't more 'professionally' rendered. By continually touching base with the client, we can explore directions that make sense strategically, as well as artistically. The client also provides an invaluable viewpoint to the process and frequently contributes a significant amount in the actual visual interpretation of the piece.

"The collaborative process and client involvement continue until the look is refined and approval is obtained to create mechanical artwork. The designer-client mix of ideas contributes greatly to an innovative result that is both graphically and strategically successful.

"Our experience has taught us that no matter how much research and expertise we have in a certain field, our clients always know their visions for their companies and what they're trying to do more exactly than we do. We add a great deal to the balance of the team by not being influenced by the viewpoint of the company.

"We create good, long-term working relationships with clients through clear, frequent communication and partnership in a project. We work very hard to establish true partnerships with our clients—not a client-vendor relationship, not a client-design guru relationship."

Rough conceptual sketch for poster. The illustrator developed the sketches for the poster after these initial roughs.

Conceptual sketches for the brochures.

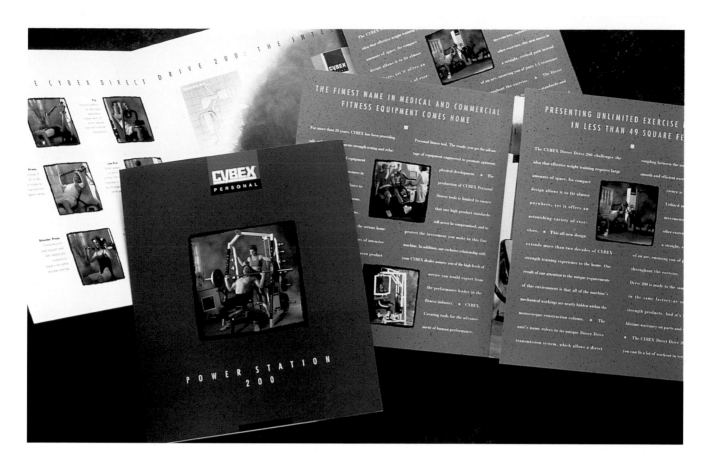

Promotional package.

"A source of inspiration for the Cybex promotional materials were collector's posters and art posters from museums. These contributed to the concept of a poster being a collectible and a work of art, rather than just a promotional piece. The result of this would be that the poster is kept by recipients and hung in their homes, creating a long-lasting promotion for the client."

For the Asics project, we worked with a Japanese producer who presented the materials to Asics. A producer 'marries' talent between Japan and other countries.

"Initially this producer reproduced our work in his Japanese-trend magazine. We kept in close touch with him during his visits to New York, showing him the latest trends. Two years later he called with the Asics project, a new line of atheleisure shoes for Japanese teens. Asics wanted a New York agency that was in touch with the trends.

"To begin, we surveyed the Japanese and American teen markets and documented U.S. and Japanese teens' shoes, high schools and publications. We had to contract an outside agency to get data on Japanese teens because the Japanese do not have a database as strong as ours here. It is very hard to find out what a fifteen-year-old Japanese buys, so we studied Japanese teen magazines.

"We got New York consumer information and documented the New York teens ourselves according to regions. We realized that the Japanese and U.S. teens were very similar and that trends travel intact from country to country.

"To show the client that we had picked trends that would transfer easily to Japan, we used comparisons in our presentations. For example, teens in Japan were wearing their hair in dreadlocks or getting it dyed yellow, just like in New York.

"Because not everyone at Asics spoke fluent English, our presentation had to be very easy to understand—visual and light on words. The flat presentation boards included illustrated spreads with very few words that showed how trends originate and are then exchanged globally. For example, we showed how rap is everywhere—Japan, Spain, New York, London, Africa, Germany. Then we presented boards that showed American influences in the Japanese market: Images of the collegiate look, sports, homeboys, rap, retro and James Dean were pulled from Japanese teen magazines.

"The boards for production and design started with a text spread that described the three themes we proposed for the shoes. The themes were 'Campus Beat,' 'Brooklyn 718' (named after the area code) and 'Heroes & Legends.' For 'Campus Beat,' we pulled photos from newspapers, magazines and campus publications, and we shot photos on the street.

"Images for 'Brooklyn 718' also came from publications, including a particular *New York Times Magazine* article about people making trends, and from photos we shot at a *Malcolm X* casting session. For 'Heroes & Legends,' we used photos of Brando, gangsters and other 1940s figures.

"After the presentation, the client wanted 'Campus Beat' to be more environmental so it evolved to 'Eco Rider' and then to 'Earthtrax.' The client liked but didn't understand the 'Heroes & Legends' theme, so we changed it to 'Miss Manhattan,' based upon an English store and clothing line called Agnes B."

Maruchi Santana and John Parham
Parham Santana, Inc.

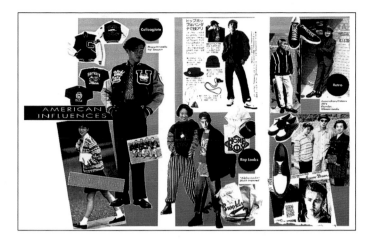

Trend and marketing shoe
development presentation for
Asics in Japan. Part 1 covers
the rise and movement of
trends and provides a profile
of the Japanese teen market.

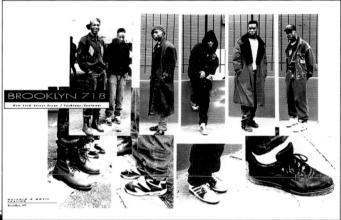

Part 2 shows the themes sug-
gested for the three product
lines and initial sketches of the
product.

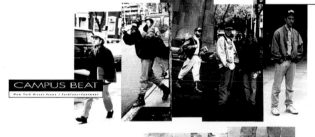

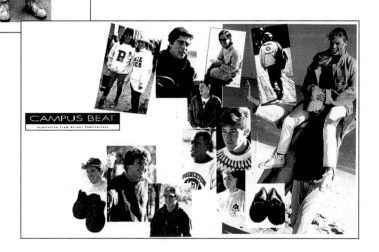

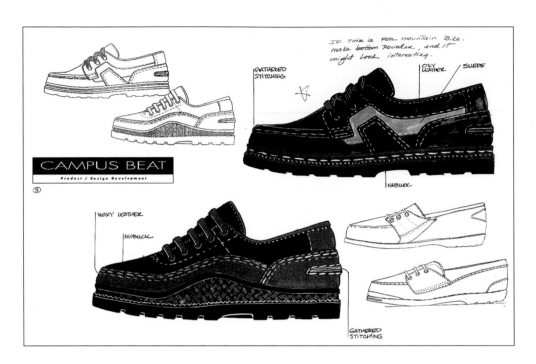

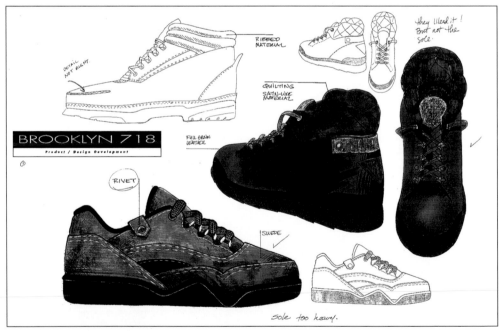

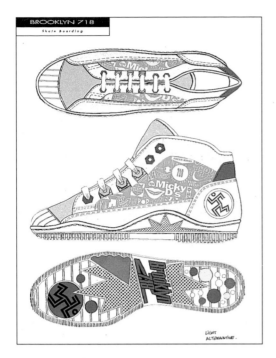

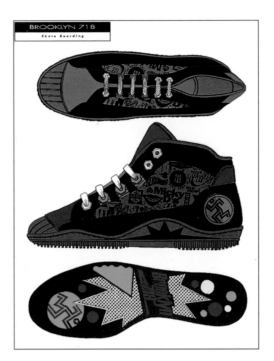

Final presentation board showing elevations for "Earthtrax" prototype.

Final "Brooklyn 718" shoe that was based upon supermarket color and graphics.

Mutual Interest
Promotes Creativity

The design work that Tom Bonauro does for the owners of the clothing store called MAC results from a mutual interest in being "esoteric and drawing on obscure things," explains Tom Bonauro. "Ours is a pro-artist relationship in which the client is extremely open to letting an artist do what he is best at. They have an appreciation of art, and they don't interject a lot after they tell you to go with an idea. They are interested in putting out pieces that show the thinking about where they want to take their store and that impart an aesthetic.

"They always have some ideas, and they are always interested in where my creative process is going. After this initial meeting, I incorporate a methodology, which could involve a concept or a certain technology, with some ideas. Then I show the client these developed ideas, supported by thumbnails or examples of my past work. I also explain the production steps involved in reaching the end piece. Eventually, the client sees the final mechanical, at which time we also decide on color and paper stock."

These two Christmas cards illustrate how well this designer-client collaboration works. The inspiration for the "Whole Lotta Love" card came from the 1970s Led Zeppelin tune. The figurative visual is a found image from historic Hindu scripture, with swirls collaged into it using computer technology. The Transcend card features an image of Joan of Arc. The message is about "coming to terms with how we live and rising above certain problematic things."

Tom Bonauro
Tom Bonauro Design

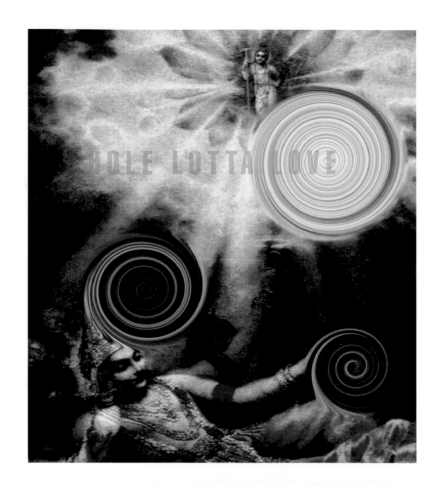

Credits

Charles S. Anderson
Charles S. Anderson Design Co.
30 N. 1st St.
Minneapolis MN 55401
(612) 339-5181;
Fax: (612) 339-3283

Turner Network Logos & Pins
Art Director: Charles S. Anderson;
Designers: Charles S. Anderson and
Paul Howalt; Illustrators: Charles S.
Anderson and Paul Howalt. ©
Charles S. Anderson Design Co.
Used by permission.

Jack Anderson
Hornall Anderson Design Works
1008 Western Ave., 6th Fl.
Seattle WA 98104
(206) 467-5800;
Fax: (206) 467-6411

Photograph of Jack Anderson
Photographer: Darrell Peterson

Cybex
Art Director: Jack Anderson; Design
Team: Jack Anderson, David Bates,
Julie Keenan and Jeff McClard;
Photographer: Darrell Peterson;
Photographer, slides reproduced in
this book: Tom McMackin. ©
Hornall Anderson Design Works.
Used by permission.

Primo Angeli
Primo Angeli, Inc.
590 Folsom St.
San Francisco CA 94105
(415) 974-6100;
Fax: (415) 974-5476

Brown & Haley Packaging
Art Directors: Primo Angeli and
Carlo Pagoda; Designers: Carlo
Pagoda, Primo Angeli, Jenny Baker,
Terrence Tong and Philippe Becker;
Photographer: Philip Salaverry. ©
1993 PAI. Used by permission.

Stuart Ash
Gottschalk + Ash International
11 Bishop St.
Toronto, Ontario M5R 1N3
CANADA
(416) 963-9717;
Fax: (416) 963-9351

*PATH, Toronto Underground
Walkway*
Gottschalk + Ash Principal: Stuart
Ash and Design Team of Diane
Castellan, Katalin Kovats and Keith
Muller; Associates Design Con-
sortium Principal: Keith Muller and
Design Team of Randy Johnson and
Merriu Price; Fabricator: King
Products, Mississauga, Ontario. ©
Gottschalk + Ash International.
Used by permission.

Elaine and Saul Bass
Bass/Yager & Associates
7039 Sunset Blvd.
Los Angeles CA 90028
(213) 466-9701;
Fax: (213) 466-9700

Visuals from Title Sequence of The
Age of Innocence
Designers: Elaine and Saul Bass. ©
Bass/Yager & Associates. Used by
permission.

Michael Bierut
Pentagram Design, Inc.
212 Fifth Ave.
New York NY 10010
(212) 683-7000;
Fax: (212) 532-0181

Photograph of Michael Bierut
Photographer: Peter Harrison. ©
Peter Harrison. Used by permission.

*"Perfectly Ordinary" Mohawk Paper
Mills*
Designers: Michael Bierut and Lisa
Cerveny; Writer: Michael Bierut;
Photographer: John Paul "Buddy"
Endress; Pentagram Coordinator:
Karla Coe; Client Coordinator
Mohawk Paper Mills: Laura Shore
and Beth Briaddy. © Pentagram
Design, Inc. Used by permission.

Tom Bonauro
Tom Bonauro Design
601 Minnesota St.
San Francisco CA 94107
(415) 648-5233;
Fax: (415) 648-4084

*"Transcend, It Is Here" 1991
Christmas Card and "Whole Lotta
Love 1992 Christmas Card*
Designer: Tom Bonauro. © Tom
Bonauro Design. Used by permis-
sion.

Brian Boyd
Richards, Brock, Miller, Mitchell
7007 Twin Hills, Ste. 200
Dallas TX 75231
(214) 987-4800;
Fax: (214) 987-3662

Brinker 1992 Annual Report
Art and Design Director: Brian
Boyd; Copywriter: Rich Flora;
Illustrators: Jack Unruh and John
Craig. © Richards, Brock, Miller,
Mitchell. Used by permission.

Art Chantry
Art Chantry Design
P.O. Box 4069
Seattle WA 98104
(206) 441-3369

Photograph of Art Chantry
Photographer: Tom Collicott

*Nemzoff/Roth Touring Artists
Promotional Brochure*
Photographers: Kevin Lohman, Mike
Urban, Melissa Calderón, Helena
Rogers, Marty Sohl, Lloyd's
Photography, Thomas Schworer and
Scott Ammon. © Art Chantry. Used
by permission.

Margo Chase
Margo Chase Design
2255 Bancroft Ave.
Los Angeles CA 90039
(213) 668-1055;
Fax: (213) 668-2470

*Logo for the Isley Brothers Album
"Masterpiece"*
Designer: Margo Chase; Typography:
Margo Chase. © Margo Chase
Design. Used by permission.

Logo for Keith Richards Ltd. CD
Designer: Margo Chase; Typography:
Margo Chase. © Margo Chase
Design. Used by permission.

*Packaging for Keith Richards Ltd.
CD*
Designer: Margo Chase. © Margo
Chase Design. Used by permission.

**Nancy Cohen & Carl Lehmann-
Haupt**
Metropolis
177 E. 87th St., #504
New York NY 10128
(212) 722-5050;
Fax: (212) 427-1938

Metropolis *magazine*
Art Directors: Nancy Cohen and
Carl Lehmann-Haupt; Photo-
graphers: Michael Ackerman and
Dan Winters. © *Metropolis*. Used by
permission.

Stephen Doyle & Bill Drenttel
Drenttel Doyle Partners
1123 Broadway
New York NY 10010
(212) 463-8787;
Fax: (212) 633-2916

"A Design Resource" Exhibition
Designers: Stephen Doyle and
Andrew Gray; Project Manager:
William Drenttel; Photographer:
Scott Francis. © Drenttel Doyle
Partners. Used by permission.

Rod Dyer
Rod Dyer Group, Inc.
8360 Melrose Ave.
Los Angeles CA 90069
(213) 655-1800;
Fax: (213) 655-9159

Fit to be Tied
Art Director/Designer: Rod Dyer;
Illustrator: Paul Leith. © Rod Dyer
Group, Inc. Used by permission.

**Roslyn Eskind, Donna Gedeon &
Nicola Lyon**
Eskind Waddell
260 Richmond W., Ste. 201
Toronto, Ontario M5V 1W5
CANADA
(416) 593-1626;
Fax: (416) 979-0421

*Toronto-Dominion Bank Annual
Report*
Design and Electronic Produc-
tion: Roslyn Eskind and Gary
Mansbridge; Illustration: Kim
LaFave. © 1992 Eskind Waddell.
Used by permission.

Bob Anderson Letterhead System
Art Director: Malcolm Waddell;
Designer: Nicola Lyon; Mac
Imaging: Gary Mansbridge. ©
Eskind Waddell. Used by permis-
sion.

*London Insurance Group 1992
Annual Report*
Art Directors: Roslyn Eskind and
Donna Gedeon; Designer: Donna
Gedeon; Electronic Production: Gary
Mansbridge. © Eskind Waddell.
Used by permission.

Mark Fox
BlackDog
239 Marin St.
San Rafael CA 94901
(415) 258-9663;
Fax: (415) 258-9681

Photograph of Mark Fox
Photographer: Mosgrove. ©
Mosgrove. Used by permission.

Logo for Jan Collier
Design and Illustration: Mark
Fox/BlackDog. © 1993, 1994 Mark
Fox/BlackDog. Used by permission.

Craig Frazier
Craig Frazier Design
600 Townsend St., Ste. 412W
San Francisco CA 94103
(415) 863-9613;
Fax: (415) 863-4946

Interstar Releasing Logo
Art Director/Designer: Craig Frazier.
© 1991 Craig Frazier Design. Used
by permission.

Julius Friedman
Images
1835 Hampden Ct.
Louisville KY 40205
(502) 459-0804

The Humana Building Flip Book
Designer/Art Director: Julius
Friedman; Photographer: Michael
Brohm. © Julius Friedman, Images,
and Donna Lawrence Productions.
Used by permission.

Joel Fuller
Pinkhaus Design Corp.
2424 S. Dixie Highway
Miami FL 33133
(305) 854-1000;
Fax: (305) 854-7300

Gilbert Paper
Design Director: Joel Fuller;
Designers: Joel Fuller, Tom Sterling
and Mark Cantor; Copywriter: Frank
Cunningham; Photographer: Gallen
Mei. © Pinkhaus Design Corp. Used
by permission.

Earl Gee
Earl Gee Design
501 Second St., Ste. 700
San Francisco CA 94107
(415) 543-1192;
Fax: (415) 543-6088

Quorum Equal Software Package
Art Director: Earl Gee; Designers:
Earl Gee and Fani Chung; Illus-
trator: John Mattos. © Earl Gee
Design. Used by permission.

Mark Geer
Geer Design, Inc.
2518 Drexel, Ste. 201
Houston TX 77027
(713) 960-0808;
Fax: (713) 960-8330

*The Power of One—A Campaign for
South Texas College of Law*
Art Director/Designer: Mark Geer;
Illustrator: Morgan Bomar; Photo-
grapher: Terry Asker; Copywriter:
Debra K. Maurer. © Geer Design,
Inc. Used by permission.

Tim Girvin
Tim Girvin Design, Inc.
1601 Second Ave., The Fifth Floor
Seattle WA 98101-1575
(206) 623-7808;
Fax: (206) 340-1837

Columbia David Lakes Signature Wine Label
Identification: Tim Girvin; Designer: Laurie Vette. © Tim Girvin Design, Inc. Used by permission.

Milton Glaser
Milton Glaser, Inc.
207 E. 32nd St.
New York NY 10016
(212) 889-3161;
Fax: (212) 213-4072

Photograph of Milton Glaser
Photographer: Stephen Green-Armytage

Sketches for Campari Poster
Illustrator: Milton Glaser. © 1992 Milton Glaser. Used by permission.

Jeffrey Goodby
Goodby, Berlin & Silverstein
921 Front St.
San Francisco CA 94111
(415) 392-0669

New Yorker *"Tattoos"*
Art Director: Jerry Postaer; Copywriter: Steve Simpson; Photographer: Dan Escobar. © Goodby, Berlin & Silverstein. Used by permission.

Diana Graham
Diagram Design & Marketing Communications, Inc.
22 W. 19th St.
New York NY 10011
(212) 242-2727;
Fax: (212) 242-2799

546 Fifth Avenue
Art Director/Creative Director: Diana Graham; Designer: Adrianne Wong; Copywriter: John Salvati. © Diagram Design & Marketing Communications, Inc. Used by permission.

Kit Hinrichs
Pentagram Design, Inc.
620 Davis St.
San Francisco CA 94111
(415) 981-6612

Simpson Paper "Quest" Paper Promotion
Art Director: Kit Hinrichs; Designer: Belle How; Photographers: Geoff Kern, Barry Robinson and Charly

Franklin; Illustrators: John Hersey, Greg Spalenka, Wolf Spoerl, Phillipe Weisbecker, Anthony Russo, Mark Selfe, McRay Magleby and Takenobu Igarashi. © Simpson Paper Company. Used by permission.

James A. Houff
James A. Houff Design
392 St. Clair
Grosse Pointe MI 48230
(313) 222-0650;
Fax: (313) 222-0471

Poster for April Greiman's Detroit AIGA Appearance
Designer: James A. Houff; Photographer: Paul Price. © James A. Houff Design. Used by permission.

Alexander Isley
Alexander Isley Design
361 Broadway, Ste. 111
New York NY 10013
(212) 941-7945

"Calling All Letterheads" Poster for Gilbert Paper
Art Director: Alexander Isley; Designer: Philip Bratter; Photographer: Geoff Spear. © Alexander Isley Design. Used by permission.

Michael Jager
Jager DiPaola Kemp
308 Pine St.
Burlington VT 05401-4740
(802) 864-5884;
Fax: (802) 863-8803

Kastle Ski Graphics and Kastle Dealer Catalog
Creative Director: Michael Jager; Art Director/Designer: Janet Johnson; Designer (Kastle Ski Graphics): George Mench; Photographer (Kastle Dealer Catalog): Scott Morgan. © Nordica USA. Used by permission.

Diti Katona
Concrete Design Communications, Inc.
2 Silver Ave., Main Fl.
Toronto, Ontario M6R 3A2
CANADA
(416) 534-9960

Zapata 1994 Annual Report
Designer: Diti Katona; Art Directors: Diti Katona and John Pylypczak;

Photographer: Deborah Samuel. © Concrete Design Communications, Inc. Used by permission.

Chip Kidd
Random House
201 E. 50th St.
New York NY 10022
(212) 572-2363

Covers for Darling *and* Come to Me
Designer: Chip Kidd. © Chip Kidd. Used by permission.

Judy Kirpich
Grafik Communications, Ltd.
1199 N. Fairfax St., Ste. 700
Alexandria VA 22314
(703) 683-4686;
Fax: (703) 683-3740

Henrik Drescher Booklet, Library of Congress
Design Team: Henrik Drescher, Judy F. Kirpich and Julie Sebastianelli; Illustrator: Henrik Drescher; Text: Harry Katz; Printing: Virginia Lithograph. © 1993 Library of Congress. Used by permission.

William Kochi
Kode Associates, Inc.
20 W. 20th, #308
New York NY 10011
(212) 366-0800;
Fax: (212) 366-0802

TDK Product Brochure
Designer/Photographer: William Kochi; Copywriter: Robert Sawyer. © Kode Associates, Inc. Used by permission.

Steve Liska
Liska & Associates, Inc.
676 N. St. Clair, #1550
Chicago IL 60611
(312) 943-4600

NEC MultiSync Monitor Brochure
Creative Director: Steve Liska; Designer: Kim Nyberg. © 1993 NEC Technologies, Inc. Used by permission.

Robert Louey & Regina Rubino
Louey/Rubino Design Group
2525 Main St., #204
Santa Monica CA 90405
(310) 396-7724;
Fax: (310) 396-1686

James Hardie Building Products
Art Director: Regina Rubino;
Designer: Robert Louey; Photo-
graphers: Henry Blackham and Lisle
Dennis. © Louey/Rubino Design
Group. Used by permission.

McRay Magleby
Brigham Young University
221 University Press Building
Provo UT 84602
(801) 378-6605;
Fax: (801) 378-5669

Photograph of McRay Magleby
Photographer: John Snyder. © John
Snyder. Used by permission.

Library Posters for Book Preservation
Designer/Illustrator: McRay Magleby;
Writer: Norman Darais. © Brigham
Young University. Used by permis-
sion.

Katherine McCoy
Cranbrook Academy of Art
500 Lone Pine Rd., P.O. Box 801
Bloomfield Hills MI 48303
(313) 645-3300;
Fax: (313) 646-0046

Signature Edition Book Covers Design
Designer: Katherine McCoy. ©
Cranbrook Academy of Art. Used by
permission.

P. Scott Makela
P. Scott Makela Words +
Pictures for Business and Culture
3711 Glendale Terr.
Minneapolis MN 55410
(612) 922-2271;
Fax: (612) 922-2367

Photograph of P. Scott Makela
Photographer: Bill Phelps. © 1994
Bill Phelps. Used by permission.

Minneapolis College of Art + Design
1993-1995 Catalog
Editor: Rebecca Hass; Designer/Art
Director: P. Scott Makela; Design
and Administrative Assistants: Alex
Tylevich and Robin Edgerton;
Photographer: Rik Sferra; Video-
grapher: Rik Sferra, P. Scott Makela
and Alex Tylevich; Typesetter: Eric
Malenfant. © P. Scott Makela Words
+ Pictures for Business and Culture.
Used by permission.

Rebeca Méndez
Design Office
Art Center College of Design
1700 Lida St.
Pasadena CA 91109-7197
(818) 584-5192;
Fax: (818) 792-1592

Photograph of Rebeca Méndez
Photographer: Stuart I. Frolick

Fellowship Poster for The Getty
Center
Concept and Design: Rebeca
Méndez; Photographers: John Kiffe
and Jobe Benjamin; Printer: Monarch
Litho; Studio: Rebeca Méndez. ©
Rebeca Méndez. Used by permission.

Clement Mok
Clement Mok designs, Inc.
600 Townsend St., Penthouse
San Francisco CA 94103
(415) 703-9900;
Fax: (415) 703-9901

Designs for the Interface for the
CollegeView™ Software
Designers: Clement Mok and Steve
Simula. © CollegeView™, Inc. Used
by permission.

Jennifer Morla
Morla Design, Inc.
463 Bryant St.
San Francisco CA 94107
(415) 543-6548;
Fax: (415) 543-7214

Swatch Watches
Art Director: Jennifer Morla;
Designers: Jennifer Morla and
Jeanette Aramburu. © Morla Design,
Inc. Used by permission.

John Norman
NIKE, Inc.
One Bowreman Dr.
Beaverton OR 97005-6453
(503) 671-6453;
Fax: (503) 671-6300

Marajuku Poster
Designer: John Norman; Art Director:
John Norman; Illustrator: Gerald
Bustamante; Typography: Benjamin
Wong and John Norman; Printer:
Riverside Press. © NIKE, Inc. Used
by permission.

Mark Oldach
Mark Oldach Design
3525 North Oakley Blvd.
Chicago IL 60618
(312) 477-6477;
Fax: (312) 477-6522

Caterpillar History Book
Art Director: Mark Oldach; Designer:
Don Emory; Writer: Max Russell. ©
Mark Oldach Design. Used by per-
mission.

Frank J. Oswald
WYD Design, Inc.
61 Wilton Rd.
Westport CT 06880
(203) 227-2627;
Fax: (203) 454-1848

Minet Group Capabilities Brochure
Creative Director: Frank J. Oswald;
Designer: Scott Kuykendall;
Copywriter: Frank J. Oswald;
Illustrators: Roy Carruthers (front
cover) and John Kleber (page one);
Cryptographer: Melissa Grimes;
Stone Carvers: Rob Day; Wing
Walkers: C.F. Payne; Futurists:
Jean-Francois Podevin; Human
Projectiles: Keith Graves; Printer:
Hennegan, Cincinnati, Ohio. © 1993
Minet Group. Used by permission.

Bryan Peterson
Peterson and Company
2200 N. Lamar, #310
Dallas TX 75202
(214) 954-0522;
Fax: (214) 954-1161

Photograph of Bryan Peterson
Photographer: Peterson and
Company. © 1992 Peterson and
Company. Used by permission.

1992 Centex Annual Report
Art Director/Designer: Bryan L.
Peterson; Writer: Sheila Gallagher;
Photographer: Gerry Kano. ©
Peterson and Company. Used by per-
mission.

Woody Pirtle
Pentagram Design, Inc.
212 Fifth Ave.
New York NY 10010
(212) 683-7000
Fax: (212) 532-0181

NEO: Innovations and Rediscovery
Editor: Maxwell Arnold; Art Director:
Woody Pirtle; Associate Art Director:
John Klotnia; Writers: Maxwell
Arnold, Jane Halsey, Peggy Knick-
erbocker, Richard Rapaport and Fred
Wickham; Designers: John Klotnia,
Ron Louie and Ivette Montes De
Oca; Photo Research: Toby
Greenberg and Melissa Hoffman. ©
Simpson Paper Company. Used by
permission.

**Robynne Raye, Michael
Strassburger, Vittorio Costarella
and George Estrada
Modern Dog**
601 Valley St., Ste. 309
Seattle WA 98105
(206) 282-8857;
Fax: (206) 281-8293

Capitol Offense
Designer: Robynne Ray. © Modern
Dog. Used by permission.

1993 Bite of Seattle Dish Towel
Designer/Art Director/Illustrator:
Robynne Raye. © Modern Dog. Used
by permission.

Walkabouts CD "Satisfied Mind"
Band Photography: Kevin Gibson;
Cover Photography: Courtesy
Grandma Sweeney's Village
Antiques; Design: Modern Dog;
Design/Art Director: Michael
Strassburger; Copywriter: Chris
Eckman. © 1993 Sub Pop. Used by
permission.

*Warner Brothers "Jazz Masters"
Magazine Advertisement*
Art Director: Jeri Heiden;
Designer/Illustrator: Vittorio
Costarella. © 1993 Warner Bros.
Used by permission.

**Forrest Richardson
Richardson or Richardson**
The Old Hess Farmhouse
1301 E. Bethany Home Rd.
Phoenix AZ 85014
(602) 266-1301;
Fax: (602) 264-0757

Scholarships 101 Software Packaging
Art Directors: Forrest Richardson
and Debi Young Mees; Designers:

Forrest and Valerie Richardson;
Copywriter: Forrest Richardson. ©
Richardson or Richardson. Used by
permission.

**Mark Sackett
Sackett Design Associates**
864 Folsom St.
San Francisco CA 94107
(415) 543-1590;
Fax: (415) 543-2860

LAX *Magazine*
Designers: Mark Sackett and Wayne
Sakamoto; Illustrator: Dave
Willardson, Willardson &
Associates. © Sackett Design
Associates. Used by permission.

**Greg & Pat Samata
Samata Associates**
101 S. First St.
Dundee IL 60118
(708) 428-8600;
Fax: (708) 428-6564

Gendex 1991 Annual Report
Designers: Pat and Greg Samata; Art
Director: Pat Samata; Photographer:
Mark Joseph; Printer: Great Northern
Design Printing. © 1991 Gendex.
Used by permission.

Gendex 1993 Annual Report
Designers: Pat and Greg Samata;
Art Director: Pat Samata; Portrait
Photographer: Marc Norberg; Printer:
Great Northern Design Printing. ©
1993 Gendex. Used by permission.

**Maruchi Santana
Parham Santana, Inc.**
7 W. 18th St.
New York NY 10011
(212) 645-7501;
Fax: (212) 645-8314

*Photograph of Maruchi Santana and
John Parham*
Photographer: Bart Gorin. © Bart
Gorin. Used by permission.

Asics Atheleisure Shoes Final Designs
Creative Art Directors: Maruchi
Santana and John Parham; Senior Art
Director: Rick Tesoro; Designer:
Jeanne Greco. © Parham Santana,
Inc. Used by permission.

**John Sayles
Sayles Graphic Design**
308 Eighth St.
Des Moines IA 50309
(515) 243-2922;
Fax: (515) 243-0212

Photograph of John Sayles
Photographer: Bill Nellans

San Antonio: Get a Feel for It
Art Director/Designer: John Sayles;
Illustrator: John Sayles. © Sayles
Graphic Design. Used by permission.

**Paula Scher
Pentagram**
212 Fifth Ave.
New York NY 10010
(212) 683-7000;
Fax: (212) 531-0181

Thomson Consumer Electronics
Partner/Designer: Paula Scher;
Designer: Ron Louie; Photographer:
Bill Whitehurst. © Pentagram
Design, Inc. Used by permission.

**Mark Schwartz
Nesnadny & Schwartz**
10803 Magnolia Dr.
Cleveland OH 44106
(216) 791-7721;
Fax: (216) 791-3654

*The Progressive Corporation 1993
Annual Report*
Writer: Peter B. Lewis The
Progressive Corporation; Art
Directors: Mark Schwartz and Joyce
Nesnadny; Designers: Joyce Nes-
nadny, Michelle Moehler and Mark
Schwartz; Photographer: Zeke
Berman; Illustrator: Merriam-
Webster, Inc. and Brian Lavy. ©
Nesnadny & Schwartz. Used by per-
mission.

**Carlos Segura
Segura, Inc.**
540 North Lakeshore Dr., #324
Chicago IL 60611-3431
(312) 649-5688;
Fax: (312) 649-0376

T-26 Promotional "Font-Kit"
Designers: Carlos Segura and Scott
Smith. © Segura, Inc. Used by per-
mission.

Gil Shuler
Gil Shuler Graphic Design, Inc.
231 King St., 3rd Fl.
Charleston SC 29401
(803) 722-5770;
Fax: (803) 577-9691

Clemson University Masters of Art Thesis Exhibition Poster
Photographer: Norm LaRusso. © Gil Shuler Graphic Design, Inc. Used by permission.

Lori Siebert
Siebert Design Assoc.
1600 Sycamore
Cincinnati OH 45210
(513) 241-4550;
Fax: (513) 241-9725

Photograph of Lori Siebert
Photographer: Michael Wilson. © Michael Wilson. Used by permission.

SDRC Packaging Before and After Shots
Designers: Lori Siebert and Barb Raymond; Illustrators: Barb Raymond and Alan Brown (Photonics). © Siebert Design Assoc. Used by permission.

Jilly Simons
Concrete
633 S. Plymouth Ct., Ste. 208
Chicago IL 60605
(312) 427-3733;
Fax: (312) 427-9053

Mohawk Paper Mills, Inc.—"Things are Going to Get Ugly"
Designers: Jilly Simons and Cindy Chang; Copywriter: Deborah Barron; Photographer: Francois Robert; Photograms: Jilly Simons and David Robson; Printer: Active Graphics, Inc. © Concrete. Used by permission.

Nancy Ann Skolos
Skolos/Wedell, Inc.
529 Main St.
Charlestown MA 02129
(617) 242-5179;
Fax: (617) 242-2135

Neocon 23 Poster and Paper Collage
Designer: Nancy Skolos; Photographer: Thomas Wedell. © 1991 Skolos/Wedell, Inc. Used by permission.

Tyler Smith
Tyler Smith Design
127 Dorrance St.
Providence RI 02903

Louis, Boston Brochure
Art Director/Designer: Tyler Smith; Copywriter: Geoff Currier; Photographer: John Huet. © Louis, Boston. Used by permission.

Clifford Stoltze
Clifford Stoltze Design
49 Melcher St.
Boston MA 02210
(617) 350-7109;
Fax: (617) 482-1171

SEGD "What Works" Conference Mailer and Identity
Designers: Clifford Stoltze, Peter Farrell and Rebecca Fagan; Photographers: Alan Shortall, Carol Naughton, Barbara Karant, R. Greg Hursley and Rudolph Janu. © 1993 Clifford Stoltze Design. used by permission.

D.J. Stout
***Texas Monthly* Magazine**
P.O. Box 1569
Austin TX 78767-6900
(512) 329-6900

Young Riders
Art Director/Designer: D.J. Stout. © *Texas Monthly*. Used by permission.

Ron Sullivan
SullivanPerkins
2811 McKinney Ave., Ste. 320
Dallas TX 75204
(214) 922-9080;
Fax: (214) 922-0044

Photograph of Ron Sullivan
Photographer: Gerry Kano. © Gerry Kano. Used by permission.

Hogwash and Beefish Packaging
Designers: Clark Richardson and Art Garcia. © 1992 Ham I Am, Inc. Used by permission.

Jack Summerford
Summerford Design, Inc.
2706 Fairmount
Dallas TX 75201
(214) 748-4638

Greiner Engineering, Inc. 1992 Annual Report
Designer: Jack Summerford; Photographer: Stewart Cohen. © Greiner Engineering, Inc. Used by permission.

Paul Sych
Faith
1179A King St. West, #202
Toronto, Ontario M6K 3C5
CANADA
(416) 539-9977;
Fax: (416) 539-9255

Poster for Sam the Record Man, and Title Page Inset for 1994 Fontshop Catalog in Germany—A Love Supreme
Designer: Paul Sych. © Faith. Used by permission.

Kan Tai-keung
Kan Tai-keung Design & Associates, Ltd.
28/F Great Smart Tower
230 Wanchai Rd.
Wanchai
HONG KONG
574-8399;
Fax: (852) 572-0199

Logo and Giftpacks for Bank of China
Creative Director/Art Director: Kan Tai-keung; Art Director: Eddy Yu; Designer: Joyce Ho; Photographers: Kan Tai-keung and C.K. Wong. © Kan Tai-keung Design & Associates, Ltd. Used by permission.

Two Girls Brand Cosmetics Packaging
Creative Director: Kan Tai-keung; Art Directors: Freeman Lau and Eddy Yu; Designer: Joyce Ho. © Kan Tai-keung Design & Associates, Ltd. Used by permission.

Rick Tharp
THARP DID IT
50 University Ave., #21
Los Gatos CA 95030
(408) 354-6726;
Fax: (408) 354-1450

Body Chemistry Identity
Graphic Designer: Rick Tharp; Illustrators: Cerstin Chatham, Susan Jaekel and Rick Tharp. © THARP DID IT. Used by permission.

Bill Thorburn
Thorburn Design
311 1st Ave. N.
Minneapolis MN 55401

Dayton's/Hudson's Oval Room
Designer: Bill Thorburn; Photographer: Don Freeman. © The Kuester Group. Used by permission.

Alan Urban
Urban Taylor + Associates
116 Alhambra Cir.
Coral Gables FL 33134-4503
(305) 444-1804;
Fax: (305) 461-2007

Photograph of Alan Urban
Photographer: Urban Taylor + Associates. © Urban Taylor + Associates. Used by permission.

Hughes Supply, Inc. 1991 Annual Report
Designer: Alan Urban. © 1991 Hughes Supply, Inc. Used by permission.

Rick Valicenti and Mark Rattin
Thirst
855 W. Blackhawk
Chicago IL 60622
(312) 951-5251;
Fax: (312) 951-8558

Photograph of Mark Rattin
Photographer: Thirstyboyz

Fluxus Vivus—The Arts Club of Chicago
Designers: Rick Valicenti and Mark Rattin. © 1993 Thirst. Used by permission.

John Van Dyke
Van Dyke Company
85 Columbia St.
Seattle WA 98104
(206) 621-1235;
Fax: (206) 623-5065

ICOS Corporation 1992 Annual Report
Art Director: John Van Dyke; Designers: John Van Dyke and Ann Kumasaka; Photographers: Randy Albritton and Jeff Corwin; Illustrator: Walker Stuart. © Van Dyke Company. Used by permission.

Michael Vanderbyl
Vanderbyl Design
539 Bryant St.
San Francisco CA 94107
(415) 543-8447;
Fax: (415) 543-9058

Photograph of Michael Vanderbyl
Photographer: Monica Lee Photography

Visuals of the Hickory Business Furniture Showrooms
Principal: Michael Vanderbyl; Design Director: Michael Vanderbyl; Project Designers: Michael Vanderbyl and Peter Fishel (Project Manager). © Vanderbyl Design. Used by permission.

Rudy VanderLans
Emigre Graphics
4475 D St.
Sacramento CA 95819
(916) 451-4344;
Fax: (916) 451-4351

Shift *Magazines*
Designer: Rudy VanderLans with Zuzanna Licko. © 1990 *Shift*. Used by permission.

Kevin Wade & Dana Lytle
Planet Design Company
229 State St.
Madison WI 53703
(608) 256-0000;
Fax: (608) 256-1975

Design Milwaukee Call for Entries
Art Directors: Kevin Wade and Dana Lytle; Designer: Kevin Wade; Project Coordinator: Catherine Donnelly. © Planet Design Company. Used by permission.

Robert Wages
Wages Graphic Design
1201 W. Peachtree St., Ste. 3630
Atlanta GA 30309
(404) 876-0874;
Fax: (404) 876-0578

Hopper Papers
Art Director: Robert Wages and Lisa Reichrath; Designer: Lisa Reichrath; Photographer: Jerry Burns, various. © Wages Graphic Design. Used by permission.

John Waters
Waters Design Associates, Inc.
3 W. 18th St.
New York NY 10011
(212) 803-0717;
Fax: (212) 627-8818

Continental-Corporate Responsibility Report
Art Director: John Waters; Designers: Colleen Syron and John Waters; Illustrator: Staphano Vitali. © Continental Insurance. Used by permission.

Index